£6.5e

OLD MAIDSTONE'S PUBLIC HOUSES

From Old Photographs

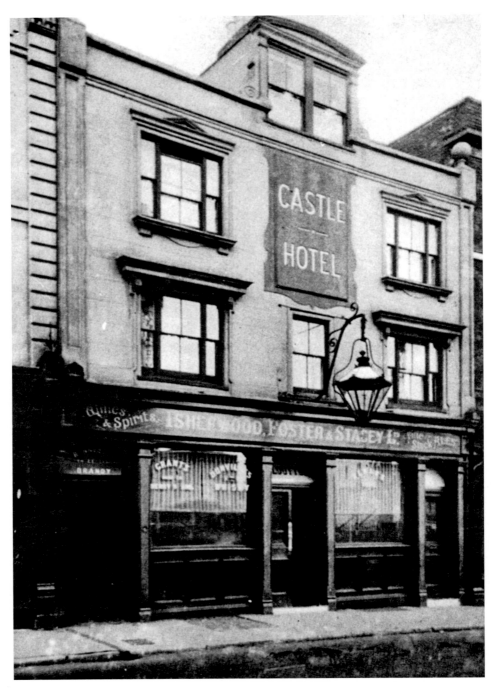

The castle was one of Maidstone's early inns. The deeds of this building went back to 1746, but there was a Castle Inn on this site in Week Street in 1650. When Fremlins took over in 1929, Major J. Outton, a boxing enthusiast was the proprietor. He had a fine selection of signed boxing photographs in the saloon bar. The Castle was closed in 1961.

OLD MAIDSTONE'S PUBLIC HOUSES

From Old Photographs

Irene Hales

AMBERLEY

First published 1982

This edition published 2010

Amberley Publishing Plc
Cirencester Road, Chalford,
Stroud, Gloucestershire, GL6 8PE

www.amberley-books.com

ISBN 978 1 84868 800 1

British Library Cataloguing in Publication Data.
A catalogue record for this book is available from the British Library.

Typeset in 10pt on 12pt Sabon.
Typesetting and Origination by FONTHILLDESIGN.
Printed in the UK.

Contents

Acknowledgements

I wish to convey my thanks to the following, without whose help this book would never have been possible.

To Courage Ltd and Whitbread Fremlins Ltd, for allowing me to borrow some of their early photographs and postcards of Maidstone's public houses and to Robin Cook and Alan Riley for all their invaluable help.

To Mr D. Kelly of Maidstone Museum for allowing me to photograph material from their archives.

To the staff of Maidstone Reference Library for their unstinting help, for allowing me access to their records and for the loan of the photo tint of the Lower Brewery.

To Kay and Eric Baldock, Mary & Roger Birchall, Chris Easton, Jack Hooper, Dorothy & Stuart Murray and Eric Potter, all from the Maidstone Postcard Club and the Maidstone and Mid Kent Philatelic Society and to James Birchall, Andrew Clarke, Amy Kelly, Mrs M. E. Marshall and Ray Yates.

Irene Hales
Maidstone, March 1982

Opposite page: The Elephant & Castle in Tonbridge Road and the White Hart next door in Hart Street, both fell victim to closure in 1917. The White Hart was sold to George Adams and became a hairdressing establishment and the Elephant & Castle became Manwarings Fishmongers.

Introduction

When John Leland, King Henry VIII's antiquary, visited Maidstone in the sixteenth century, he commented that the town was 'full of inns', but if he could have returned three centuries later he would have seen many more.

This book provides an illustrated background of some of the breweries, the old established hostelries and the later public houses and beerhouses of Victorian Maidstone.

A list of the recorded drinking houses of 1882 is included at the back of the book for reference.

The information relating to Maidstone's public houses, as recorded by earlier generations, is sometimes confusing or contradictory. Whilst every effort has been made to ensure the accuracy of the contents of this book, I would be glad to hear from readers who can supply additional information, pictures etc, so that they can be included in future editions. Please write to me care of Amberley Publishing.

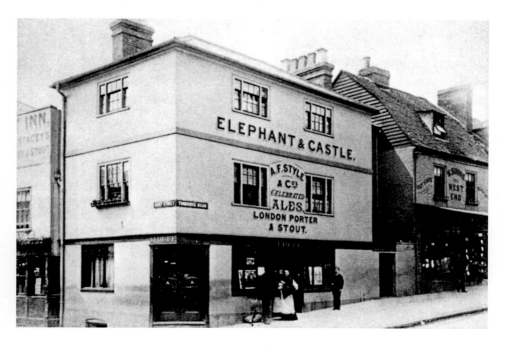

Chapter 1

Maidstone's Breweries

In Tudor times brewing was a domestic craft, practised in the home, and it was not until the middle of the seventeenth century that it became a large scale activity marked by the establishment throughout England of many breweries.

The two earliest known breweries in Maidstone were the Lower Brewery in Lower Stone Street owned by John Saunders in 1650 and the Upper Brewery which occupied the lower part of Brewer Street. The latter may or may not have been the older of the two as it was not mentioned until several years later when it belonged to the Crispe or Cripps family.

It was during the time of the Cripps ownership that the proprietorships of these two breweries merged through marriage and by the early 1700s both breweries were owned by the Brenchley family; a few years later they were separate establishments once again.

The Lower Brewery was owned by the families of Brenchley and Stacey throughout most of the eighteenth and nineteenth centuries. During this period trade flourished particularly when a large military camp was stationed at Coxheath.

It is interesting to note that in 1799 Flint Stacey, the owner of the brewery at that time, erected a triumphal arch in Maidstone for King George III to pass under en route to Mote Park to review the troops. The arch, situated at the bottom of Gabriel's Hill, close to Stacey's house and a few yards from the Brewery Gates, was a solid structure, handsomely decorated with flowers and hops, from which hung a large portrait of George III, the whole surmounted by an enormous crown, on which the Royal Standard was hoisted.

About the year 1820, the Upper Brewery was bought out by the Lower Brewery, the buildings were demolished and the land was sold.

In 1891 the ownership of the brewery was vested in a limited liability company of which the directors were Major Isherwood, Major Foster and Captain Edward Stacey with Mr A. E. Keyes as managing director. The company maintained approximately 100 public houses in Kent, several of which were in Maidstone.

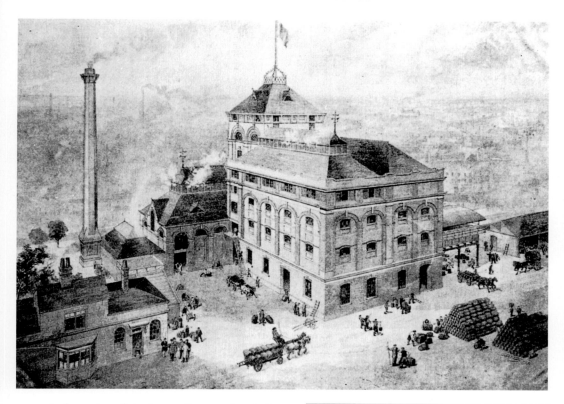

A photo tint of the Lower Brewery in 1898 when Isherwood, Foster & Stacey were the owners. The decorative wrought ironwork at the top of the building was salvaged when the brewery was demolished in the early 1970s. It has since been erected over the wishing well in Brenchley Gardens. Prior to demolition, the brewery had been used as a furniture warehouse for many years.

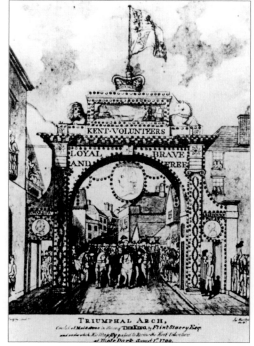

A water colour drawing of the Triumphal Arch by J. Barlow. A print of the arch is in the British Museum.

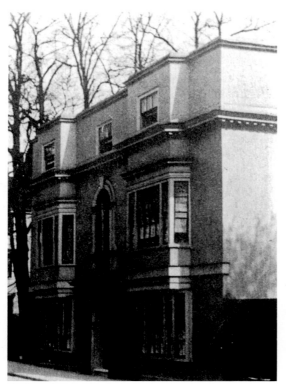

The Brewery House was one of many distinguished properties that used to line Lower Stone Street. It was situated near the old ironwork bridge over the Len and until it was demolished about seventy years ago, this residence still contained a large powder room that had been used by the dandies many years earlier.

Oast Houses in Corrall's Hop Gardens, College Farm at the corner of Tovil and Hayle Roads photographed over a hundred years ago. This was just one of the Maidstone farms that supplied hops to the local brewers.

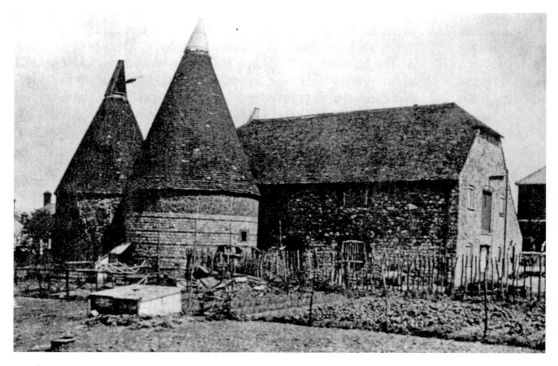

Chapter 2
E. Mason &
Co.'s Brewery

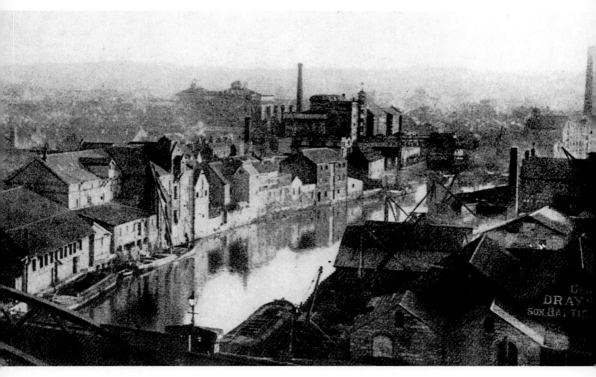

This postcard, of industrial Maidstone in the early 1900s, shows Mason's Brewery at the river's edge on the corner of St Faith's Street and Waterside. Fremlins Brewery can be seen immediately behind.

MASON'S

FIRST PRIZE MEDAL
ALES and STOUT.

BREWED with ENGLISH HOPS

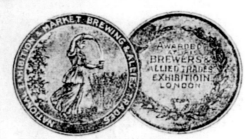

AWARDS:

LONDON, October, 1921—First Prize, Silver Medal & Diploma **For ALE**
LONDON, October, 1910—First Prize, Silver Medal & Diploma **For STOUT**
PARIS, 1911—Grand Prix, Gold Medal & Diploma **For ALES & STOUT**
ROME, 1911—Grand Prix, Gold Medal & Diploma **For ALES & STOUT**

E. MASON & Co.,
(Established Over a Century)

Waterside Brewery, Waterside,
MAIDSTONE. Telephone 3800

Four generations of the Mason family brewed for more than a century at the Waterside Brewery at the lower end of St Faith's Street. They also had a shop at 50 High Street. Their beer won several medals in open competition and the firm's trade mark – a maid with cap tails streaming behind her, carrying a glass of beer on a tray – came to be recognised as the guarantee of a good reliable brew.

In 1906 William T. Martin joined the firm as a boy straight from school and became partner to Allen J. Groll-Mason. The partnership remained in existence until the firm of E. Mason & Co. was taken over by Shepherd Neame Ltd in 1956. Shortly afterwards the brewery was demolished and the site became a municipal car park.

Shepherd Neame Ltd, established in 1698, still on part of its original site at Court Street, Faversham and Whitbread Fremlins Ltd, also of Court Street, Faversham (Rigden's former brewery) are the only surviving breweries in Kent.

Chapter 3

The Medway Brewery

The original Medway Brewery was built by William Baldwin of Stede Hill between 1799 and 1806 on a piece of land, leased from the Earl of Romney, at West Borough near the bridge and St Peter's Church. The latter was used as a store room by the brewery until it was re-opened for public worship in 1837.

When William Baldwin died in 1834, the business was carried on by his son and from 1836 to 1882 the company traded under the following names:- Baldwin & Godden 1836-1847, Baldwin, Godden & Holmes 1847-1858, Baldwin & Holmes 1858-1866 and Holmes & Style 1866-1882.

The Medway Brewery prospered under the ownership of A.F. Style who assumed complete control when Holmes died in 1882. Between 1887 and 1899 the brewery was modernised and extended, the work being interrupted by a fire which occurred in 1894. In March 1899, the amalgamation took place between A.F.Style and E. Winch of Chatham making the new firm of Style & Winch the dominant brewer in the Maidstone area.

New malthouses were built in St Peter's Street in 1908 and in 1914 new bottling stores were opened at Acorn Wharf, Rochester. After the First World War, Style & Winch manufactured cider at a factory at Ashford. In the early 1920s electric light was installed at the brewery and the head offices were enlarged. The Dartford Brewery was jointly purchased by Style & Winch and the Royal Brentford Brewery in 1924 and later came under the full control of Style & Winch.

In 1929 began Style & Winch's association with Messrs Barclay Perkins Ltd from Southwark. Subsequently the firm became part of the Courage, Barclay & Simonds group. Brewing ceased in the 1960s and a bottling plant was maintained on the site. In 1974 the bottling plant was transferred to Parkwood Estate and the following year the large red brick Medway Brewery was demolished. The Maidstone Society, which was formed in 1972, tried to save the old brewery, but to no avail. All that remains today is the ornate red brick building which stands in the Broadway.

Courage Ltd, formed by the merger of several companies, including Courage, Barclay Perkins & Simonds is now the fifth largest brewer in the country and maintains 5,300 tied houses. It became a subsidiary of Imperial Group Ltd in 1972.

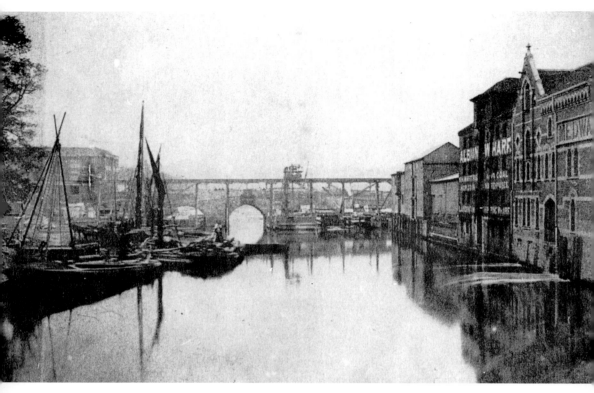

The Medway Brewery in 1879 when the present Maidstone Bridge was being erected.

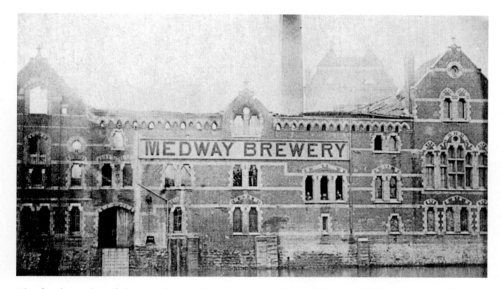

The fire brigades of the Maidstone Volunteers, the Kent Office and Hobbs, were quickly on the scene when the Medway Brewery caught fire on Sunday evening, 1 April 1894. When they arrived the brewhouse was almost gutted, but Captain Gates' and Captain Spencer's men were soon at work with the water making every effort to save the adjoining property. After about three hours' hard work, the fire was under control, but not before Fireman Woolley narrowly escaped from being burnt to death when a wall gave way under him.

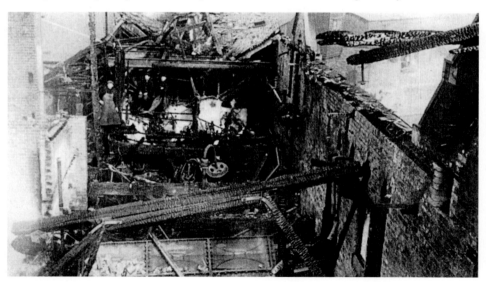

Another incident, was the emerging of a cat enveloped in flames; the hose was quickly turned on to the poor animal but the force of the water drove it back into the fire, where no doubt it was burnt to death. A possible explanation as to the cause of the fire was that the weather vane was struck by lightning during a thunderstorm which passed over Maidstone just before the discovery of the fire. The damage amounted to over £10,000 but was fortunately covered by insurance.

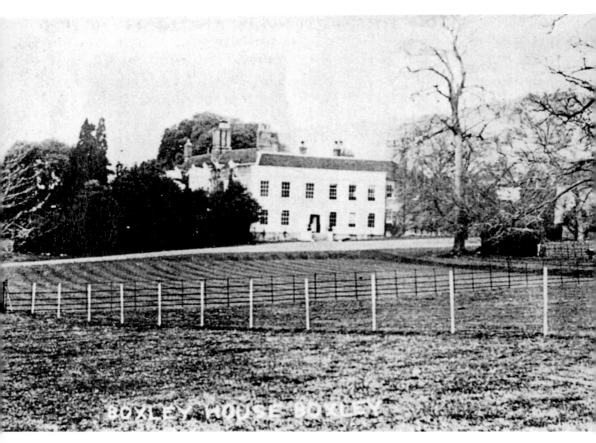

Albert Frederick Style, the great grandson the 2nd Lord Romney and a distant relative of the Wyatt family, purchased his ancestors home, Boxley House in his early days at the Medway Brewery. The Style family had previously lived at Wateringbury Place where they returned again after the Second World War. Boxley House is now a licensed hotel and restaurant.

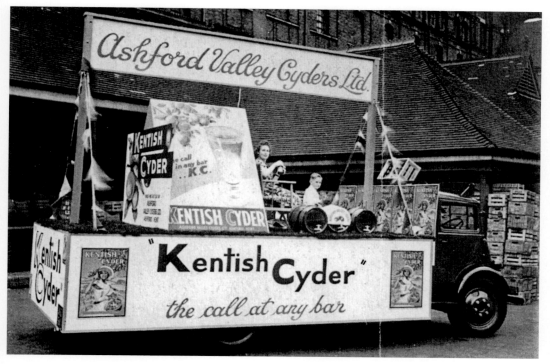

A carnival float advertising 'Kentish Cyder' manufactured by Style and Winch at Ashford.

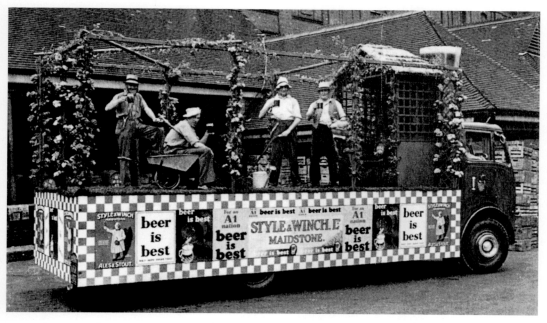

These two floats were used to advertise Style & Winch of Maidstone at local carnivals just after the Second World War.

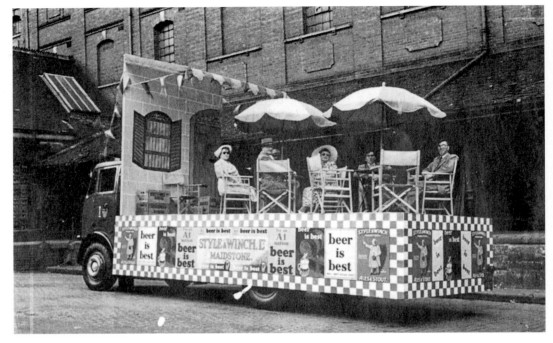

All three photographs were taken by Sweatman Hedgeland Ltd at the Medway Brewery.

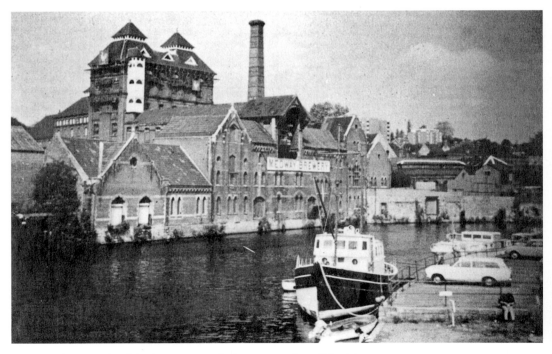

A photograph of the brewery just before it was demolished in 1975.

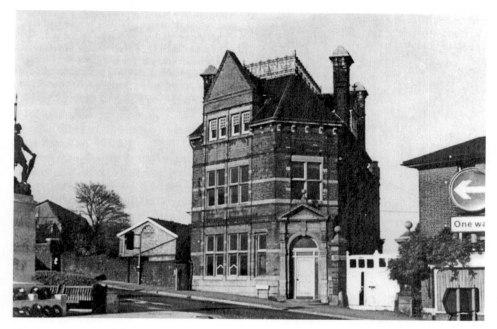

The last remnant of the Medway Brewery stands forlorn and empty today. For many years, this work of George Witcombe, monumental sculptor from King Street, housed the busy offices of Style & Winch and Courage Ltd.

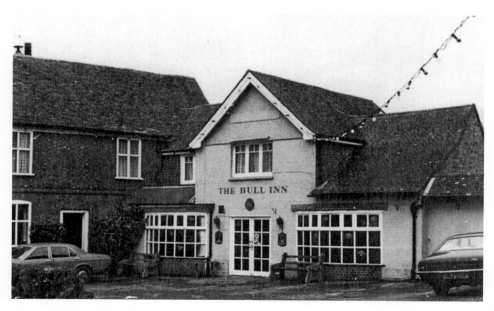

Situated on the edge of Penenden Heath, the Bull Inn is very popular today. Bar facilities are available seven days a week, but this was not so when it was Fremlins only public house. It only operated on a six day licence, being closed on Sundays.

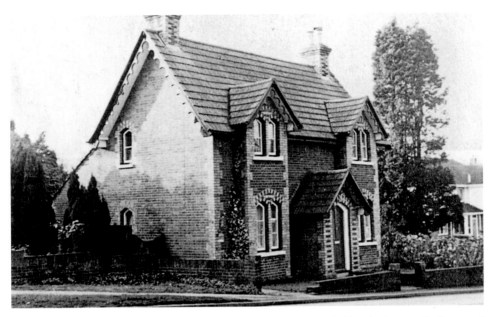

Overlooking the Heath was the extensive premises of Heathfield, which was the home of Ralph Fremlin for many years. This view shows the Lodge which would have been used by one of his household staff.

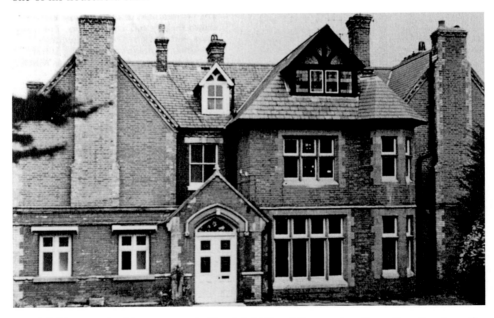

Heathfield House had its entrance in Heathfield Road (known locally as Fremlins Lane for many years). The house had its own dairy, stables and well laid-out gardens. Even to this day, a few elderly Maidstonians remember the parties that they attended here as children. Several years later the name of the house was changed to Kenward and the property became a Dr Barnardo's Home. The house stands empty today.

Chapter 4

Fremlins Brewery

During the eighteenth and nineteenth centuries, several breweries were established in the Maidstone area; some thrived while others declined. It was in one of these derelict breweries that Ralph James Fremlin, a man of strict religious principles, started his successful business in 1861.

Ralph was born at Warden House, Wateringbury, in 1833 and educated at Sutton Valence Grammar School. He acquired a property, which had been established in 1780 in Earl Street, from John Heathorn. After carrying out essential reconstruction and re-equipment he commenced brewing operations. At the start he was his own brewer, engineer, accountant and roundsman. He delivered his fine ales by horse and cart to local residents, but he did not supply public houses, for his ethical outlook saw little virtue in the Victorian beerhouse. (In fact Fremlins only ever had one public house, the Bull at Penenden Heath, up to the time of the take over of Leney's & Flint's licensed properties in 1926.)

In 1863 Ralph bought another smaller brewery at the lower end of Earl Street from Messrs Baldwin, Holmes & Style; this purchase included a public house called the Jolly Waterman which was probably disposed of at the time. Ralph's business flourished to such an extent that he had to enlist the help of his three brothers, Richard, Walter and Frank, as partners and in 1871 the new Victorian brewery was built.

A branch office was opened at Rochester and in the succeeding years the branch system was extended to several towns in the South East. The Fremlin Brothers were pioneers in supplying bottles and gallon jars of beer for the family trade and their business was built up mainly on this principle. In 1910 Ralph died and his brothers carried on the business, the demand for their products spreading over an ever widening area. Richard died in 1915.

After the First World War it became necessary for the Company to broaden its policy. In 1920 a private company was formed, to be known as 'Fremlin Bros Ltd'. The original Board comprised Messrs Walter & Frank Fremlin, Henry Hills and A.L. Brown both of whom had joined the old firm of Fremlin Bros as boys straight from school.

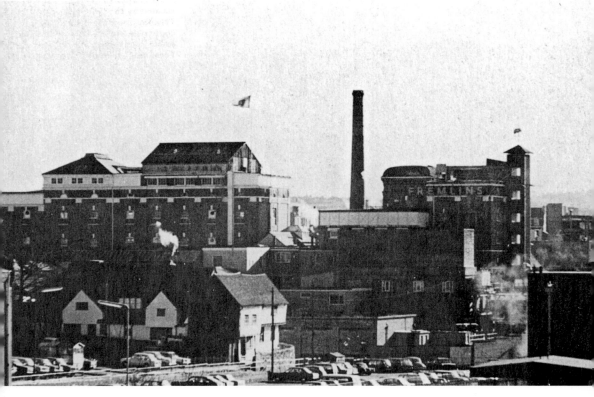

This view shows Fremlins Victorian Brewery (known as the Pale Ale Brewery) just before demolition. Note the elephant on the top of the weather vane.

Walter Fremlin died in 1925 and the following year Messrs G.T. Cook, the head brewer and A.P. Squire, grandson of Ralph Fremlin, joined the Board of Directors. Also in 1926, an arrangement was made with Alfred Leney & Co. Ltd of Dover and Flint & Co. Ltd of Canterbury, whereby Fremlins took a 36 year lease of all the former companies' licensed properties and supplied them from the Maidstone Brewery. In 1927, Mr Alfred C. Leney and Major Claud Leney, a nephew and a great nephew of Ralph Fremlin, joined the Board.

In 1928, when Frank Fremlin retired from the business, the private company went into voluntary liquidation and restarted as a public company. Mr Henry Hills was elected the first Chairman and Managing Director of the new Company. Several off-licences were acquired at this time and in 1929 by the outright purchase of Isherwood, Foster & Stacey Limited of Maidstone, a large number of public houses came under the control of the Company, many in the Maidstone area.

After Corpus Christi Hall, Earl Street, was vacated by the Grammar School in 1871, Fremlins took over the building for a cooperage. An adjacent building was used to stable their horses. The Hall is now Whitbread Fremlins Community Centre and Restaurant.

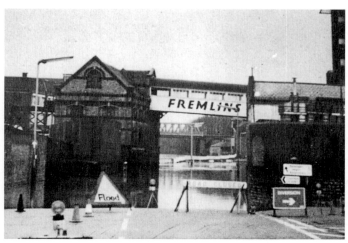

A photograph taken of the 1974 floods in Fairmeadow, showing Fremlins covered bridge. This bridge and the connecting riverside building were demolished when the new road system and St Peter's Bridge were built in 1978.

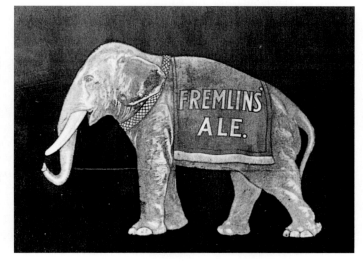

This elephant is one of a pair on Whitbread Fremlins gates in Waterside. The family crest of an elephant, dating back to the Fremlins connection with the East India Company and the coat of arms of another branch of the family, were combined to form Ralph Fremlin's trade mark.

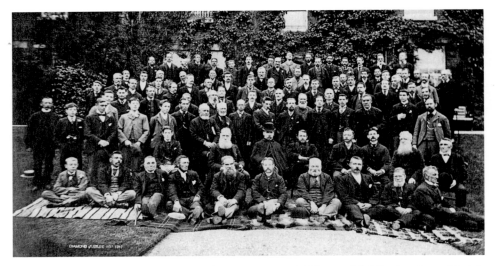

A photograph taken on the occasion of Queen Victoria's Diamond Jubilee in 1897 of Ralph Fremlin and some of his employees in the garden of Heathfield House.

Mr A.C. Leney took over as Chairman in 1930 on Mr Hills' retirement and Mr G.T. Cook and Major C. Leney as Joint Managing Directors; Mr A.L. Brown became a Joint Managing Director at a later date. In 1934 Fremlins acquired a controlling interest in Findlater & Mackie & Co. Ltd, wholesale and retail beer, wine and spirit merchants of Hove. In 1938, Harris Browne Ltd, the Hadley Brewery, Barnet, was purchased to be followed in 1939 by the purchase of the business of T.F. Adams & Son of Halstead, Essex, which included 40 public houses. Frank Fremlin died in 1942 at the age of 90, having maintained a keen interest in the firm even after his retirement.

In 1949 the share capital of George Beer & Rigden Ltd of Fayersham was bought and in 1959 the on-licences held on lease from Alfred Leney & Co. Ltd, Dover, were bought outright. In 1960, the Company acquired the capital of Frederick Leney & Sons Ltd of Wateringbury, thus bringing another 189 public houses into the group. In the same year the wine & spirit firm of George Prentis & Sons of Maidstone was purchased. The two wine & spirit subsidiaries merged under the name of Findlater Prentis Ltd, in 1962. In 1965 the Company's licensed houses in Essex were leased to Whitbread in return for the draught beer trade in 83 Whitbread houses in the Tunbridge Wells and East Sussex area.

Fremlins Ltd, merged with Whitbread & Co. Ltd in 1967 and when brewing ceased at Maidstone on 15th September 1972, brewing operations were maintained at Faversham and Wateringbury. In 1980 Fremlins' Victorian Brewery was demolished and in November 1981 the Wateringbury Brewery discontinued brewing activities; but today there is a new distribution centre and headquarters for Whitbread Fremlins Ltd, sited where Ralph Fremlin started his family business 120 years ago.

Whitbread Fremlins is one of many breweries that have been taken over by Whitbread & Co. Ltd in recent years. Whitbread is now the third largest brewer in the country, with 44 different national and local brews. It possesses 7,000 public houses and its Beefeater Steak Houses are expanding at the rate of one a week.

Chapter 5

The Control of Liquor

Liquor has been subject to special control in England for many centuries. In 1552 laws were passed for the special regulation of public houses selling beer and ales. They were required to obtain a licence from the magistrates, who had power to withhold licences if they thought fit.

In 1689 the government granted the right for anyone to manufacture spirits in this country on payment of excise duties. This led to an immense growth in the consumption of spirits. Gin dealers hung out signs announcing that customers could get drunk for a penny, dead drunk for twopence and have straw to lie on for nothing. The evil became so great that spirit sellers were ordered to be licensed, as beerhouse keepers already were. Licence fees were set at £20 a year. Licences were renewable annually. These restrictions proved inadequate and the licence fee was raised to £50. This created an enormous illicit trade in spirits and as there were not enough prisons to hold the offenders and there was danger of armed rebellion, the act was repealed.

In 1830 the government, believing the best way to discourage spirit drinking was to encourage the use of beer, passed an act permitting any householder to open a beer shop on paying an excise fee of two guineas (£2.10p). Consequently many beerhouses came into existence and there was a great increase in the consumption of beer, but it did not deter the spirit trade.

In line with the national trend, a large number of licensed houses were opened in Maidstone and in the 1860s when Gladstone was responsible for passing the act which allowed grocers to sell spirits, wines and bottled beers for consumption off the premises, several off-licences also appeared. By 1905 Maidstone had 175 licensed premises in spite of the fact that in 1869 the law had changed once again and an act had been passed compelling all beerhouse owners to apply for licenses.

Temperance Societies and the Council of Evangelical Free Churches in Maidstone considered that the excessive number of licensed places led to the encouragement of chronic drunkenness and social disorder. Between 1905 and 1914, twenty licensed houses were referred to the County Compensation Authority and had their license suppressed. £15.158.12s.6d compensation was paid to the licensees and the owners of the houses, this fund for compensation was provided by an annual levy on all holders of off-licences.

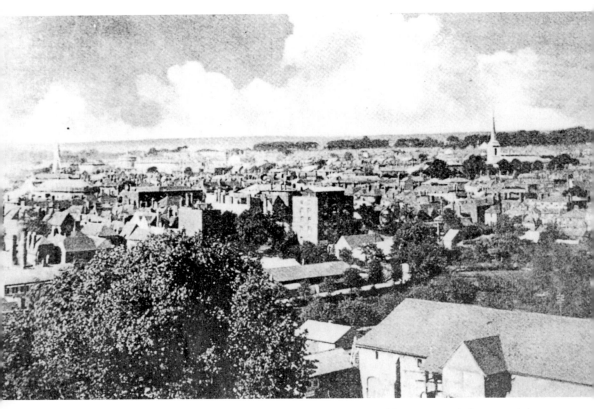

The square brick building in the centre of this picture. situated between Bank Street and the present Palace Avenue, was Maidstone's gin distillery. It was operated by George Bishop, a native of the town, from 1785 to 1818. After it closed, the premises were converted into a flower mill. The building was demolished in 1926. This view was taken from All Saints' church tower in 1890.

During the First World War extra control of liquor was introduced to encourage national economy and efficiency. A Central Control Board was set up and several measures were initiated.

The tax on beer was increased from 7s.9d per standard barrel to 25s. The spirit duty went from 14s.9d to 29s.6d while the alcoholic content of spirits and beers was greatly reduced. War beer was of such poor quality it was hardly possible for it to intoxicate an average man.

Before the war, public houses were open all day. The time was· now cut to 2½ hours at mid-day and about 3 hours at night. The sale of spirits in bottles was allowed only from 12 noon to 2.30 p.m. on five days a week with no sale at weekends. Clubs were subject to the same restrictions as licensed premises. Fortunately these regulations and restrictions were accepted by the public as a war time necessity and on the whole were well observed.

In 1774 Thomas Grant erected a distillery at Dover, but after a cliff fall in 1853, the business was moved to Hart Street, Maidstone, where a new distillery and warehouses were built. Although Grant's Morella Cherry Brandy had been produced for many years at Dover, it was not until the move to Maidstone that it became world famous. The secret formula for the drink was passed down through the Grant family for more than 100 years. In the very early days of advertising, Grant's produced this slogan: Always welcome - keep it handy Grant's Morella Cherry Brandy. The sherry bottling company of Luis Gordon have since taken over the premises in Hart Street. When this advert was produced Grant's Morella Cherry Brandy was 3/6d a bottle.

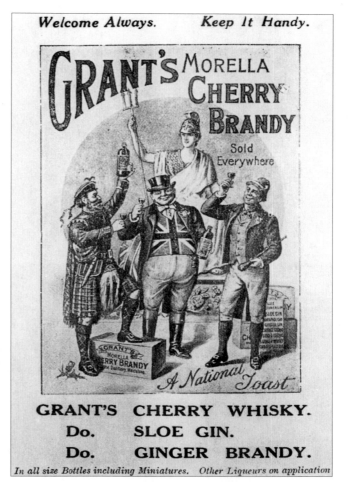

The result of strict control and limitation of all supplies during the war was very marked. Drunkenness fell rapidly and diseases associated with intemperance showed' a marked and growing decline. Whereas the amount of alcohol consumed in England in 1913 was 76,000,000 gallons, it dropped to 30,600,000 in 1918.

Following the national pattern, several more public houses became redundant in Maidstone and with inducement from the Control Board, the sale of food and light beers were encouraged in the remaining licensed houses.

The Board was forced to carry on after the war, but its authority had, however, gone and the public now protested. Great concessions were made and the quantities of spirits and beer released for public consumption largely increased but the post war years never saw the return of the excessive drinking habits of the previous generation and drunkenness became the exception rather than the rule.

Chapter 6

Style's Public Houses

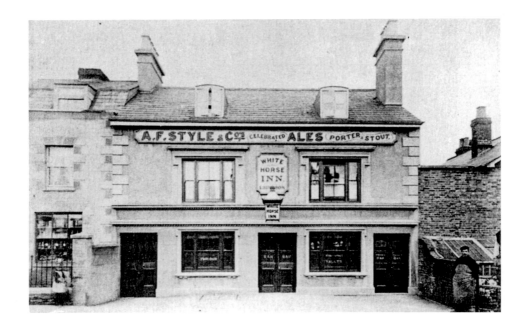

Many fully licensed houses and beerhouses were maintained by the Medway Brewery when A.F. Style took sole control in 1882. The White Horse, London Road, was at that time, part of a small community on the edge of town. Always a busy inn, it was the first to be encountered when entering Maidstone from London. This was not always so, as a previous inn called the Seven Stars used to stand where Summerfield House is now. The White Horse is a detached property today, the shop having made way for the entrance to the car park. The row of cottages behind the inn has disappeared, yet the original public stables are still intact. The Saloon and Public Bars and the Jug & Bottle are now one large room. During the early 1800s there was another public house called the Blacksmiths Arms on Rocky Hill.

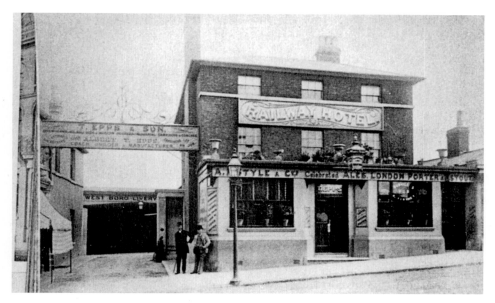

Shortly after the South Eastern Railway came to Maidstone, the Railway Hotel was opened in West Borough. When this photograph was taken about 1890, Timothy Epps was the proprieter. He also managed the Victoria Hotel in Week Street.

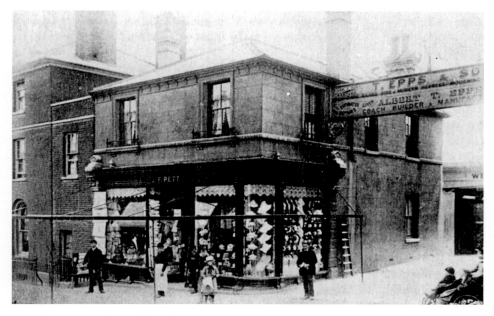

Timothy Epps, with the help of his son, Albert, also ran the West Borough Mews and Livery Stables that were behind the Railway Hotel and J.F. Pett's drapers shop. Carriages of all descriptions could be hired including: wagonettes, omnibuses, funeral hearses and a four horse char-a-banc.

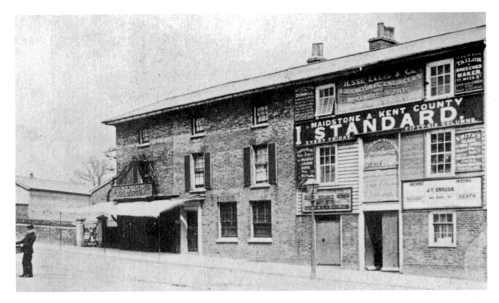

A view taken from the Railway Hotel about 1890 looking towards the London Road. This was before the Medway Brewery building was erected. George Bunyard, the nurseryman, occupied the shop nearest the railway lines and his seed and potato store was two doors further down. The wisteria which can be seen at the side of Bunyard's shop is probably the same one that is there today.

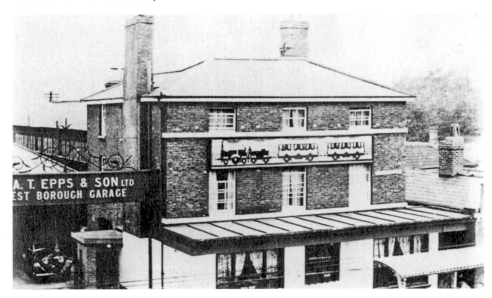

Several years later, when Style & Winch were the brewers, a colourful picture of a railway engine and two carriages was displayed on the front wall of the Railway Hotel. In 1975 the hotel was closed and re-opened in October 1976 as a free house although it is still owned by Courage Ltd. On market days, because of the close proximity of Maidstone Market, the Railway Hotel now stays open until 4 pm by special licence.

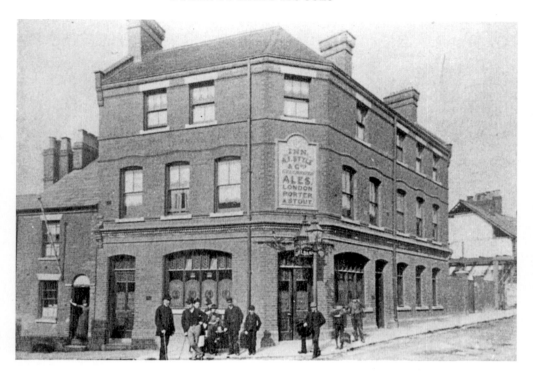

Above: The Ancient Druids Inn, which has Druids' heads etched on the windows, has always been a distinctive public house at the top of Brewer Street. Luke Dann was landlord when this photograph was taken in 1890. It is still possible to see the top of the ventilation shaft of the railway tunnel which passes beneath the premises. The Ancient Druids is now run by the same management as the Railway Hotel but it is not a free house. The Eagle is still on the opposite corner of Brewer Street and the Rose has remained in Wheeler Street. Two small beerhouses in Brewer Street, the Little Star and the Warwick Arms, were closed in 1914 and 1916 respectively. A postcard showing the Little Star, can be seen on page 16 in *Old Maidstone* vol.2.

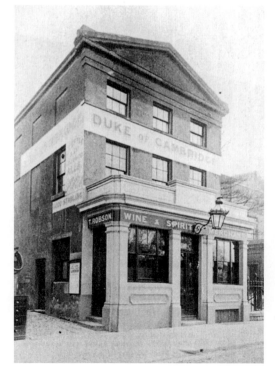

Right: The Duke of Cambridge, Sandling Road, about 1890. This public house had its premises in the Old County Assembly Rooms and in April 1921, it became the first Ex-Serviceman's Club in the county when it was opened by General Lord Byng of Vimy. It is now occupied by H. Goodsell & Sons.

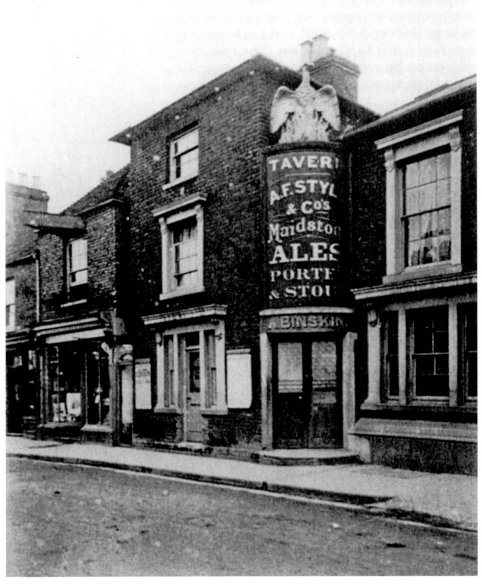

A Phoenix arising from the ashes, on the Phoenix Tavern in Sandling Road, was a well-known Maidstone landmark a hundred years ago. This beerhouse and a similar establishment a few doors away called the Prince Albert, closed in the early 1900s. Most of this property has long since been demolished. The Reindeer and the Parliament House Inn were situated in Wharf Lane during the last century. Wharf Lane disappeared some years ago, it was a turning off Sandling Road almost opposite the Phoenix Tavern.

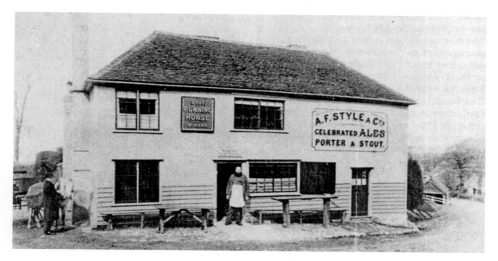

This view shows William Ward, standing in front of his country pub, the Running Horse, on the old Chatham Road at Sandling about 1890. In 1938, a new public house was built with Norfolk reed thatch, soft interior lighting and comfortable seating.

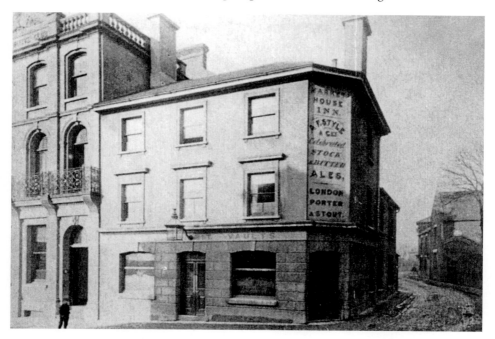

The Market House, Earl Street in 1885. This has always been a busy inn, frequented by visitors to the concert hall, cinemagoers to the Empire and local businessmen. For many years the Market House was managed by the Fletcher family who had strong connections with the local rugby club. Recently an attractive roof garden has been added to the side. The Coal Barge Inn occupied this corner during earlier years of the last century and the King's Arms, the Unicorn, the Prince Alfred and the Gardeners Arms were on the opposite side of Earl Street. The Rose of Denmark was just around the corner in Market Street until the early 1900s.

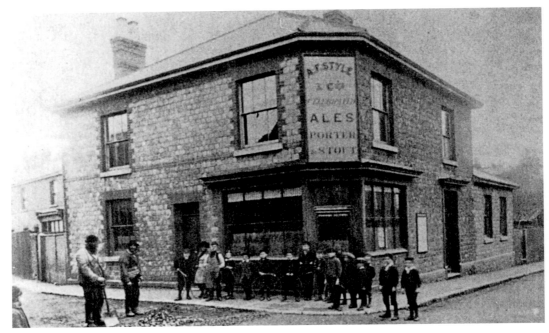

Children line up, clutching their hoops, to watch the road menders at work outside the Artillery Arms, Thornhill Place in 1890. This Victorian beerhouse, which later became a fully licensed house, is still open for business.

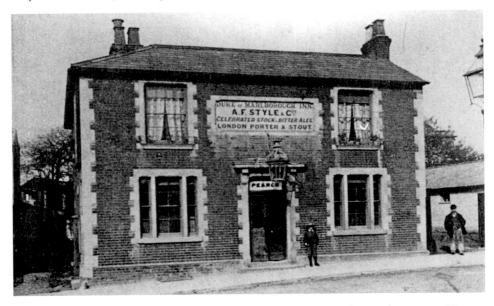

The Duke of Marlborough, Union Street was managed by Joseph Pearch in 1882. He was a new landlord having just taken over from Tom Clifford, a horse dealer. On the opposite side of Union Street, next to the Citadel, was a small beerhouse called the Hope & Anchor. It closed in the early 1990s.

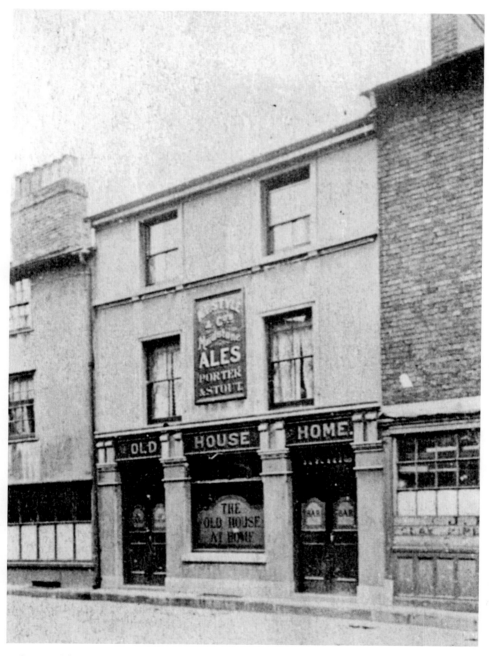

Before Pudding Lane was widened in the 1920s, the Old House at Home was little more than a cottage pub. Steps led down into the small, well scrubbed bars. Eventually the house became fully licensed, the bars were made into one large room and the exterior was re-designed. Some of the beerhouses that evaded closure in the early years, had to wait until the 1940s before they received their wine & spirit licences. Another small beerhouse called the Wharf Tavern was in Pudding Lane prior to 1882.

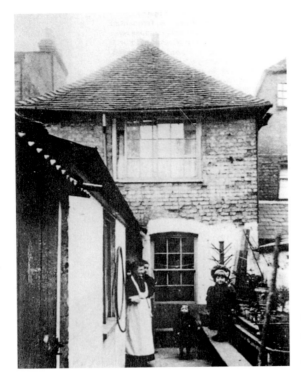

The King family in the back yard of the Old House at Home in the 1890s. Notice the iron hoops on the outhouse wall.

The Kent Arms at the lower end of Medway Street, had a fair trade from the river in its early days but at the beginning of the First World War it was referred to the Compensation Authority for redundancy and was closed on 31st December 1914. Lloyds Overseas Branch have their building on this site today.

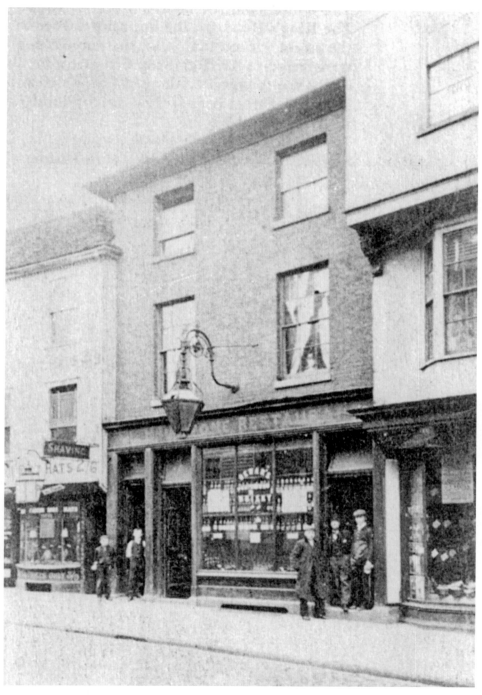

The Maidstone Restaurant, Bank Street in 1897, when a good market dinner cost a 1/-, york hams and cold joints were 2/-per lb and whisky and gin were 15/-per gallon. Notices on the window refer to extensive alterations and the shop next door is under new management.

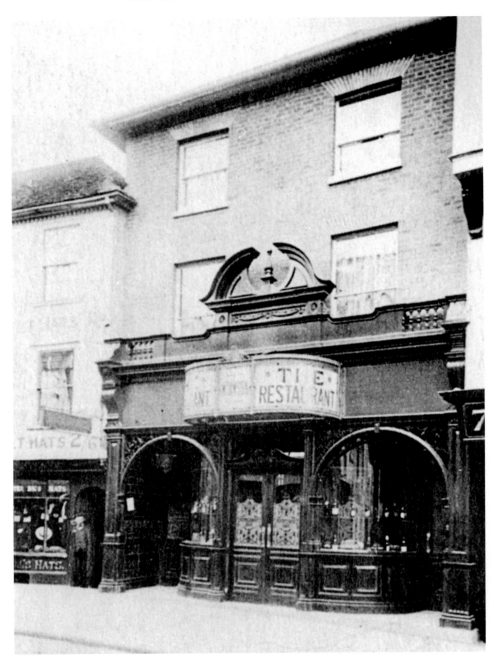

A few months later, the Restaurant had been modernised, central doors and an ornate wooden front had been added. Luncheons were served from 12 till 4, afternoon teas from 4 to 5 and dinner a la carte from 6 to 9. Wines, spirits, draught & bottled ales and stout were available. Private dinner parties, ball suppers and wedding breakfasts were catered for. A few years later the Restaurant was renamed the Medway Hotel. Trade has not been good in recent years and the building is now up for sale.

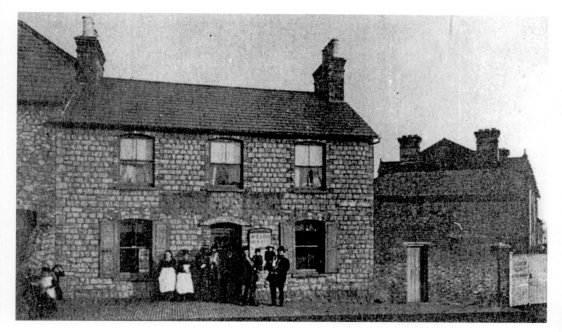

Nearly a hundred years ago, William Waghorn and family posed for the photographer outside the Fox Tavern in Hartnup Street. Two generations of the Tree family managed these premises between the First World War and the 1950s.

The White Swan, St Peter's Street in 1879. The King's Head, on the opposite corner of the street, closed that year, the name being transferred to 46 High Street (previously called the Admiral Rodney/Rodney's Head). The High Street premises became redundant in 1914. The Seven Greys, which was also in St Peter's Street in 1879, is still in business.

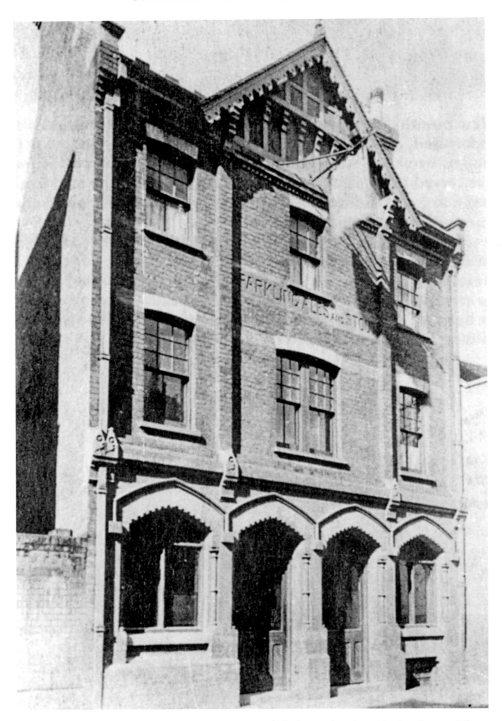

A few years later, a new White Swan superseded the earlier humble beerhouse. These premises are occupied by the Acorn Café today.

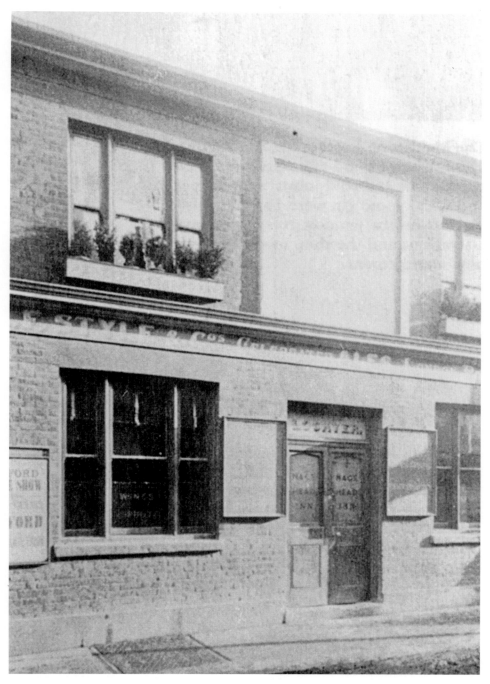

The Nags Head, Week Street in 1887. This old fashioned inn stayed virtually unchanged until it closed in the 1950s. A Nag's Head had occupied this site since the middle of the seventeenth century. Brentford Nylons shop has taken its place today. Prior to 1908, the Windsor Castle occupied the premises next door but one to the Nag's Head.

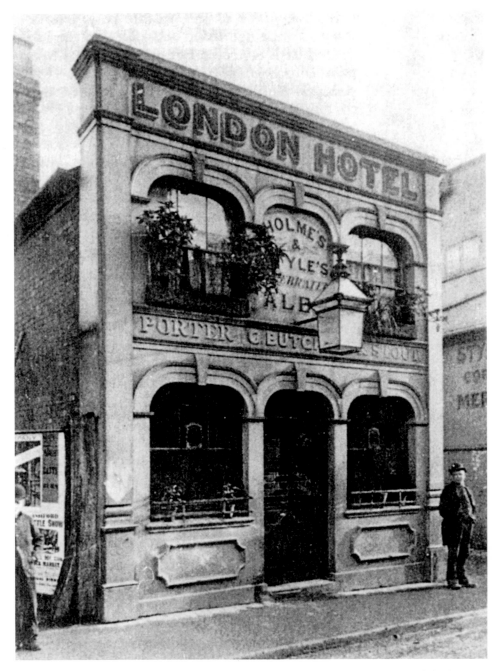

The London Hotel, 110 Week Street, when George Butcher was the licensee and the brewers were Holmes & Style. In the 1930s a new public house was built further back from the road, to replace the Victorian building. It re-opened as the London Tavern. Apart from the Victoria Hotel on the corner of Station Road, the London Tavern is the only remaining public house in Week Street.

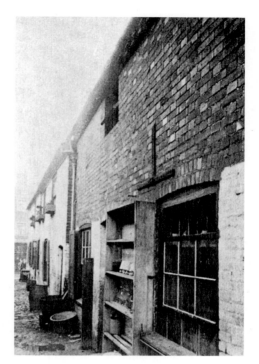

This view shows the passageway at the side of the old London Hotel in 1880. There were two more drinking houses near these premises, the Tichborne Arms at 106 Week Street and the Hearts of Oak (formerly the Robin Hood) at 102 Week Street.

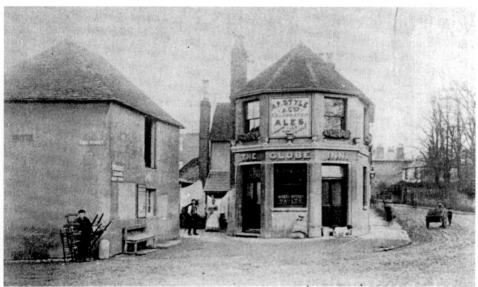

The public house on the comer of Knightrider Street and Mill Street was most probably called the Globe because of its shape. When John Potter was landlord in the late 1800s, the Globe was noted for its excellent wine & spirit vaults. The inn had closed by 1920 and the extension of the Baptist Church is on this site today. Mill Street had two other public houses during the 1800s, the Golden Lion which closed before 1882 and the Duke of Wellington which became redundant in 1914.

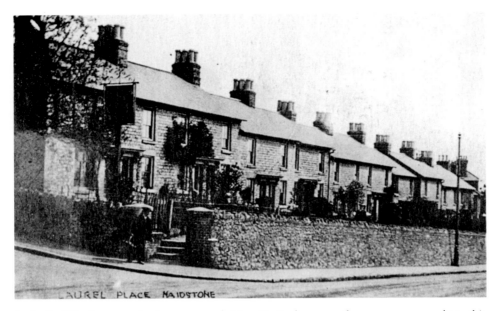

Style & Winch were the brewers and Mrs G. Farley was the manageress, when this photograph of the Walnut Tree, Laurel Place, Tonbridge Road was taken in the late 1920s. This is probably one of the smallest public houses left in Maidstone today. The Admiral Gordon is still on the opposite side of Tonbridge Road.

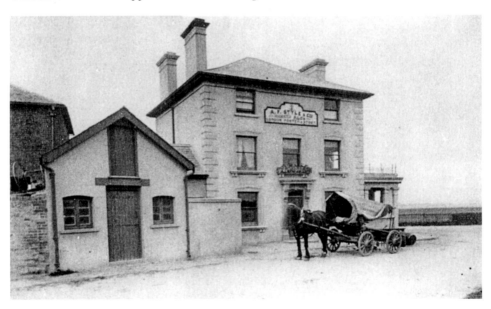

A delivery of ale, by one of Style's draymen, to the Wheatsheaf Inn on the corner of Loose Road and Sutton Road in the 1880s. This area, known as Shernold Pond, was very quiet and rural. As a result of the municipal tramway terminating at the King's Head in 1907 and later this location becoming a major junction for trolleybuses, the Wheatsheaf became a very busy inn on a very busy corner.

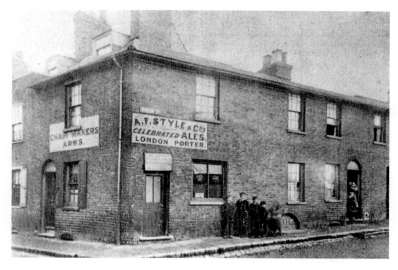

The Chairmakers Arms on the corner of Salem Street and George Street in 1885. The name of this beerhouse was probably derived from the local chairmaking industry that was in this area during the 1800s. Edwin Stone's Chair Manufacturing Co. occupied 10 and 11 Salem Street in 1882. Other members of his family, who lived at 12 & 13, were also in the business. There were two more beerhouses in George Street, the Britannia Arms, which was later re-named the Brown Jug and the Prince Albert. All three were closed in the early 1900s.

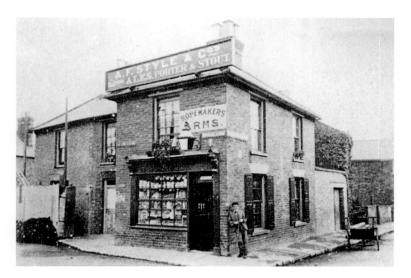

In 1882, the Ropemakers Arms in Bower Lane was a small beerhouse and general shop combined. William Cook, the proprietor, was also a coal merchant. This was another licensed property named after a local trade. James Clifford, a ropemaker, had his rope and twine grounds in Bower Lane during the last century. A sign above the shop points to Tovil Station which used to be at the end of the lane. A small ale house called the Farmers Arms was recorded in this area in 1872. It stood in Tonbridge Road near the site of West Borough Congregational Church, which was formerly the site of the old Bower Farm buildings.

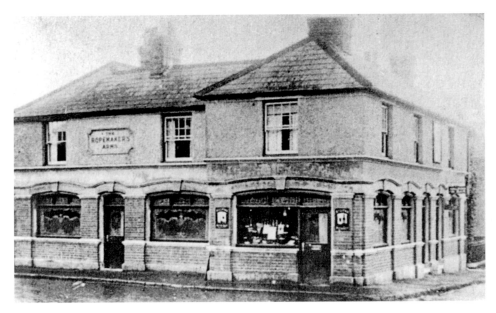

The Ropemakers Arms was enlarged and modernised after the amalgamation of Style & Winch. These premises were transferred to Whitbread Fremlin on 30th June 1972.

The Anchor & Hope, Bower Lane has had strong connections with the boating and fishing activities on the Medway at Tovil. In the 1880s, when Edward Avery was the proprietor, it was the headquarters of the Maidstone Angling Society and boats of every description were let on hire.

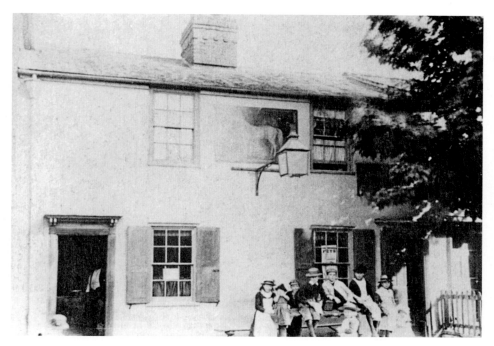

The White Horse, Tovil, when Henry Jury was the landlord about 1890. Tovil had six public houses a hundred years ago but only three have survived. These are the Victory in Church Street, the Royal Paper Mill (formerly the Royal Papermakers Arms), Tovil Hill and the Rose Inn on Farleigh Hill (which was the end of the line for the Maidstone to Tovil tram service). The Old English Gentleman and the Foresters Arms closed in the early 1900s and the White Horse closed in the 1950s.

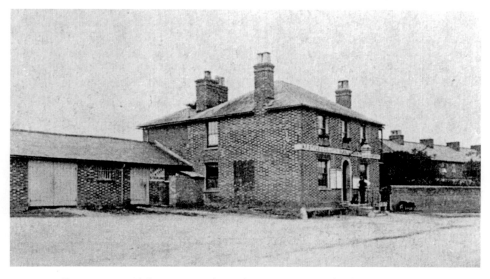

Horse traffic was catered for extensively at the Fountain, Tonbridge Road in 1890 but by July 1904, this location had become the terminus for the Maidstone to Barming Tramway.

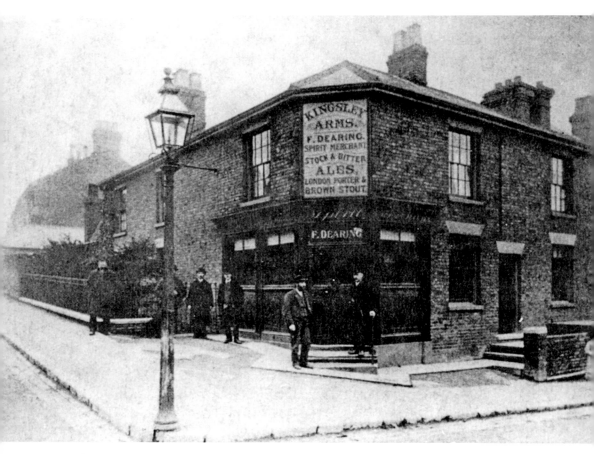

The Kingsley Arms, Melville Road about 1890. These premises and the surrounding housing estate were named after Kingsley House which was in this part of town until 1855. Kingsley House was the home of John Brenchley, a former owner of the Lower Brewery during the early years of the nineteenth century. A smaller public house, the Marquis of Lorne, was also on this estate until it became redundant in 1915. It is interesting to note that there was a public house called the General Kingsley in Week Street in 1839, possibly named after the General who owned Kingsley House until 1769.

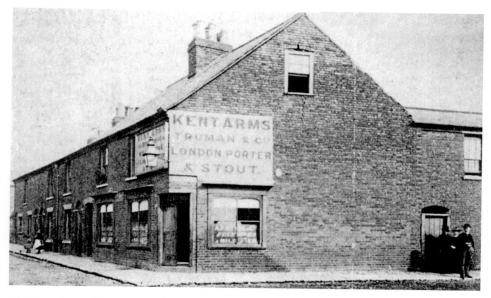

The Kent Arms, Wyatt Street claimed to be the Best House in Maidstone for Truman & Co.'s London Porter & Stout but it also stocked A.F. Style & Co.'s Fine Ales & Mild Beer. This house was proposed for redundancy in 1916 but it was still open in the 1950s.

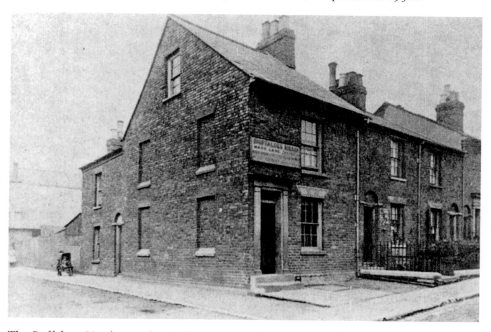

The Buffaloes Head was also in Wyatt Street. These two small Victorian alehouses were typical of many that catered for a class of customer who would probably not have been welcome in the larger establishments. In general it was the smaller beerhouses that were selected for redundancy. Observe the bricked up windows to save the Window Tax. Also in Wyatt Street prior to 1882 was the White Horse.

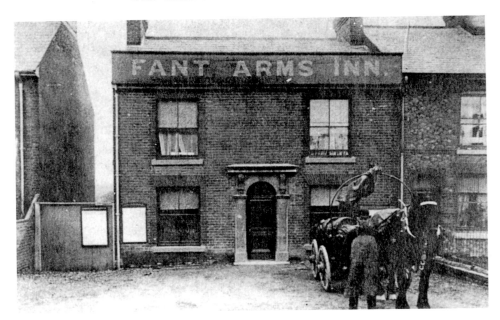

A driver of one of Albert Style's drays poses for the camera in the forecourt of the Fant Arms in Upper Fant Road in 1890. These premises were recommended for redundancy in 1917, but it never occurred. Mr & Mrs Clark managed this public house during the Second World War and a relative of theirs ran the Rising Sun in Marsham Street. Both of these locals are open today. There was another small beerhouse in Upper Fant Road before 1882 called The Queen's Own run by Samuel Sisly, a dairyman.

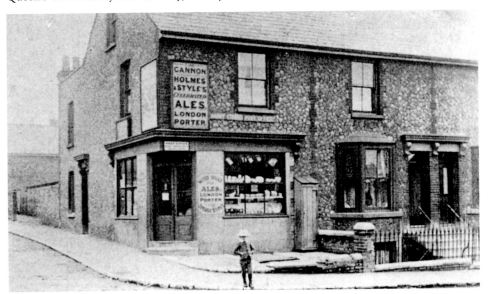

Hardy Street Post Office was known as the Cannon in 1870 and was a noted house for Ales, London Porter and Double Stout. This very early photograph was taken when Holmes & Style owned the Medway Brewery.

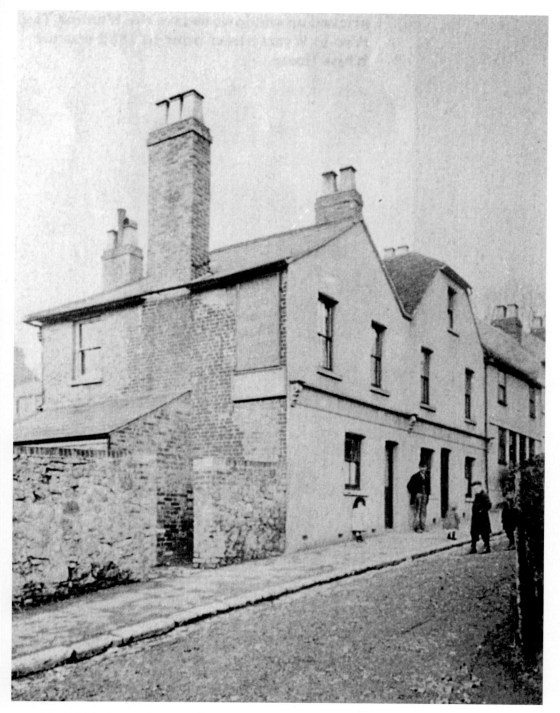

The British Queen, Square Hill, was a busy lodging house and beerhouse in 1890 run by
Job Moon.

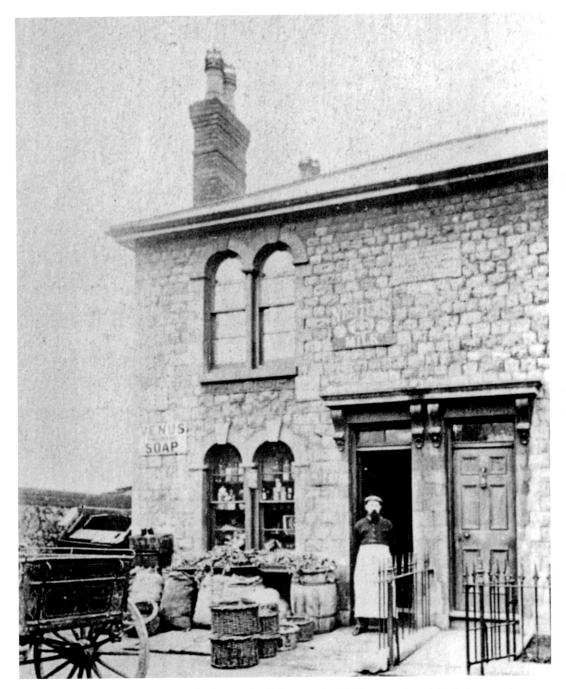

The Medway Brewery supplied several off-licences in Maidstone when A.F. Style was the owner. This photograph shows Alfred Chantler standing outside his new general shop and off-licence at 40 Waterlow Road a hundred years ago. These houses had just been erected by Sir Sidney H. Waterlow Bart. M.P. The shop closed after the Second World War.

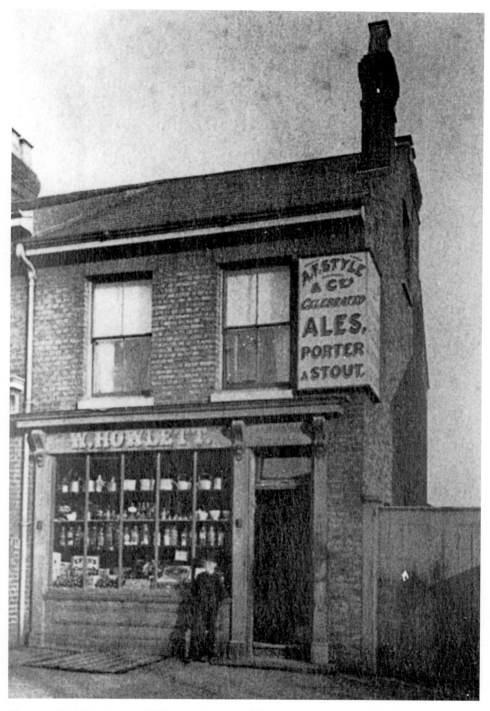

Eleanor Grigsby's shop in Whitmore Street sold toys, groceries and sweets as well as her supply of Maidstone Ales, Porter & Stout.

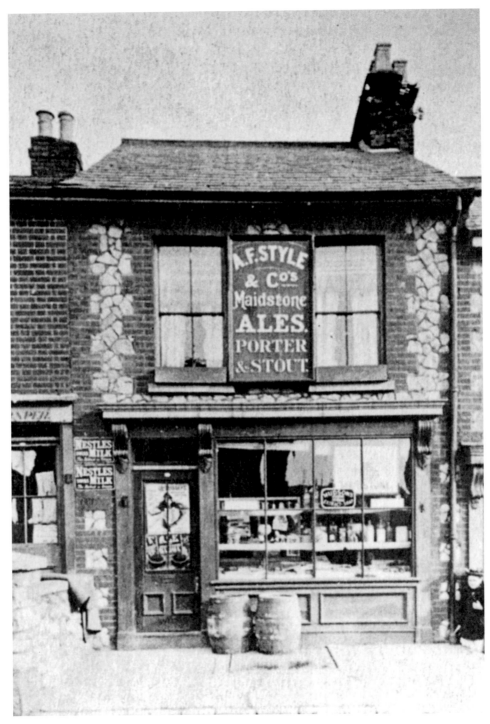

W. Howlett ran the general shop and off-licence at 16 Bower Street in 1890.

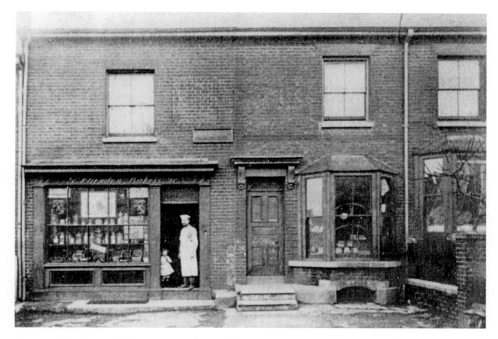

George Planden, a baker, managed two shops in Bower Street, a general stores at no. 77 and a bakers at no. 79. The advert for A.F. Style, Maidstone, bearing the trade mark of the Doulton type stoneware jug with a glass of beer alongside, was dearly displayed in his window. (The jug and glass of beer were incorporated in the weather vane on the top of the Medway Brewery.)

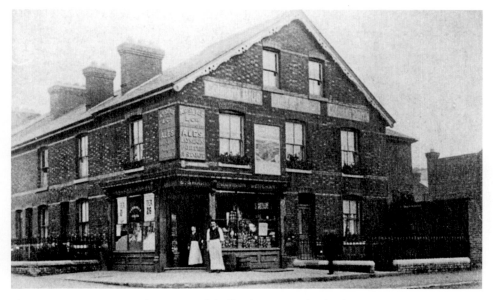

Sharp's grocery store on the corner of Holland Street and Wheeler Street was also a Style's off-licence in 1887. It is still an off-licence at the present time.

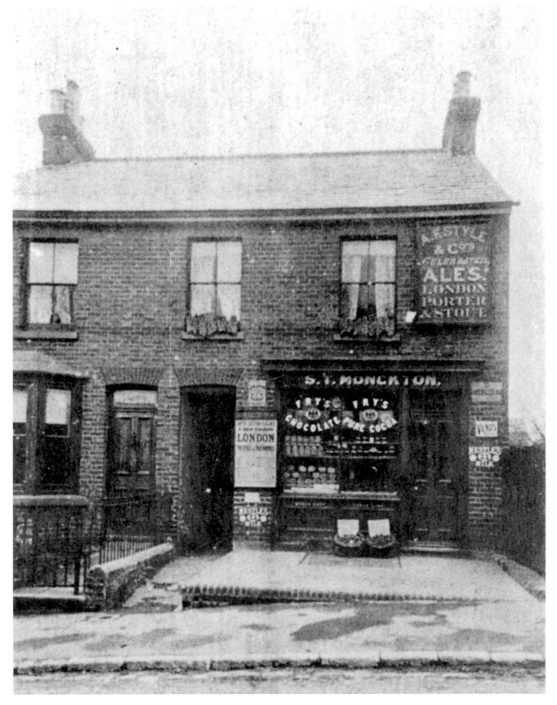

Monckton's shop in Charlton Street sold a wide range of goods from Venus Soap to Balloon Yeast.

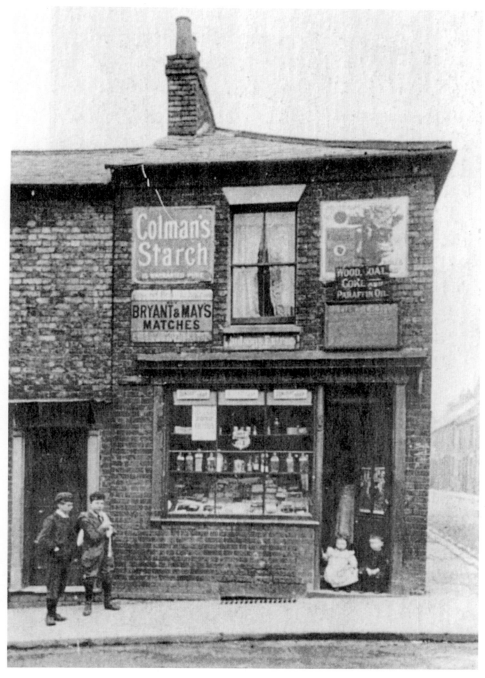

The Castle family had this general shop and off-licence on the corner of Brewer Street and Camden Street in 1890. Their hot drinks at 1d a glass were as popular with the children as the ales, porter and stout were with their parents. James Stone kept a small beerhouse called the Good Intent in Camden Street in 1882.

Chapter 7

Isherwood, Foster & Stacey Public Houses

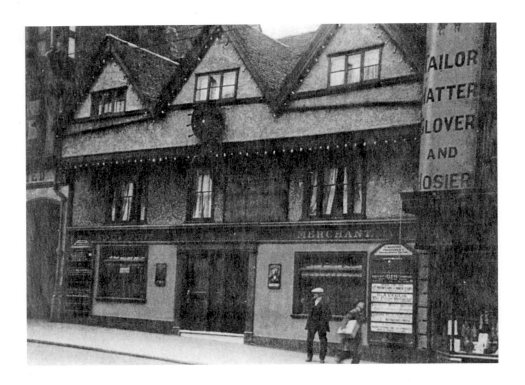

When Fremlins purchased Isherwood, Foster & Stacey's Lower Brewery in 1929 most of the older public houses in Maidstone came under their control. The Sun Inn, originally called the Swan, was in Middle Row in the sixteenth century and it still preserves most of its old gabled front. Claude Porter was landlord in 1929 and he was well remembered for his maroon coloured suit which had been made specially to match his large maroon car. He was a familiar figure when he motored down Bank Street stopping at the florists for his weekly bunch of flowers to decorate the Sun.

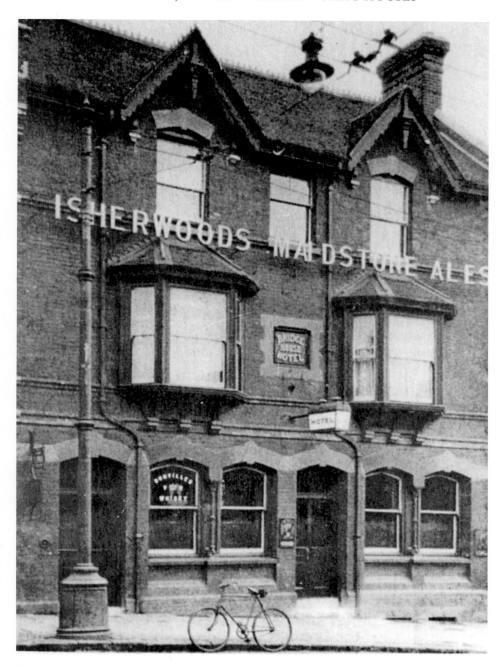

When the 'new' Maidstone Bridge was built in 1879, the Prince of Wales public house was renamed the Bridge House Hotel. It had its own stables, two adjoining shops and every accommodation for commercials. There were also spacious dining, club, smoking, billiard and bath rooms. The manager was Robert Dunk, ex-landlord of the King's Head on the corner of St Peter's Street. When Fremlins took over in 1929 the proprietor was W.J. Baker. On 31stMay 1972, the hotel was transferred to Courage Ltd.

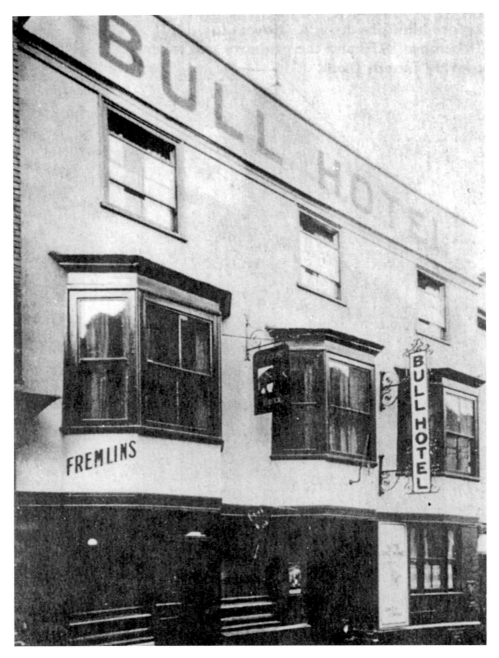

In the seventeenth century there were five inns on Gabriel's Hill, the Bull, the Ship, the Bell, the George and the Chequers. The Bull is the only one that has remained. This inn was purchased by Flint Stacey in 1800 and belonged to the Lower Brewery until Fremlins took control in 1929. W.J. Efford was then the proprietor and a few years later, his eldest son took over the management of the Cherry Tree in Tonbridge Road. Major alterations were carried out at the Bull in 1960 and again in 1978-9.

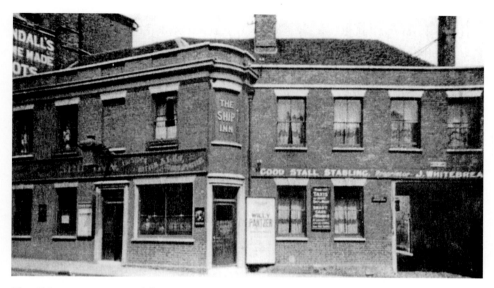

The Ship, once renowned for its Fine Stock and Bitter Ales closed on 26th January 1975. It re-opened as a Wine Bar/Bistro. The entrance to the stables is now replaced by a glass doorway into Stoneborough Shopping Centre. The Maid of the Mill, named after Lenworth Mill (formerly Padsole Mill), was in Padsole Lane in 1882. The inn had closed by 1903 and the mill was demolished in 1981.

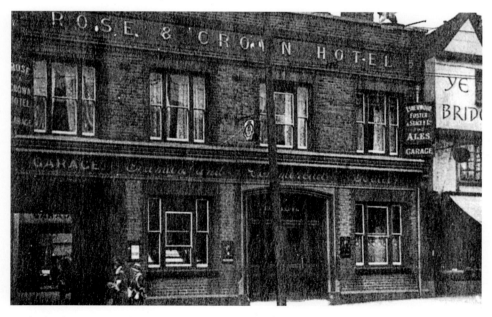

As far back as 1608, a house bearing the sign of the Rose & Crown stood on this site in the High Street. For many years it was a coaching inn with extensive stables at the rear. Charles Brissenden, a very keen huntsman, was landlord in 1929 and his father had managed the hotel for many years before him. The Rose & Crown closed in December 1970 and the property was taken over by Lloyds Bank.

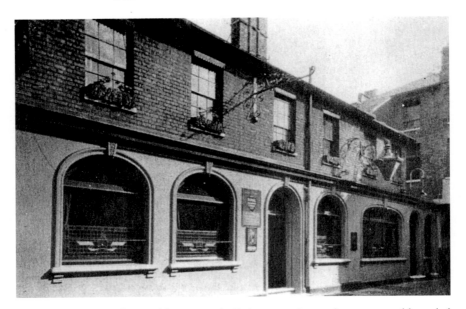

The Mitre Inn, Market Buildings, was built in 1826. Its predecessor, a gable-ended building, used to be in the High Street. When the new Mitre opened Abraham Spencer was the proprietor and the inn was advertised as follows: 'Family Hotel and Commercial House, with good stabling and convenient lock-up coaches. An excellent billiard table is fitted up in a commodious part of the house.' When the Fire Station was situated in Market Buildings earlier this century the Mitre was a convenient meeting place for the firemen.

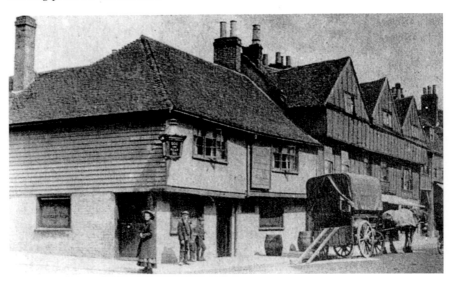

The Dog & Bear, on the corner of Church Street and King Street, was closed for compensation in December 1913. The property was bought the following March by Walter Grey Kite, house-agent, valuer & accountant, for £600. Safeways Supermarket is on this site today.

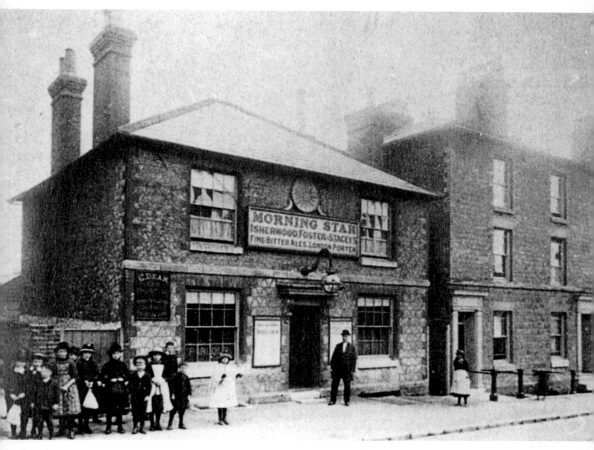

Children pose for the photographer outside the Morning Star in Boxley Road in the late 1890s. This public house closed during the First World War when it was under the management of Frederick Peters. Flats are now on the site. The Royal George, at the lower end of Boxley Road, near the prison wall, is still in business.

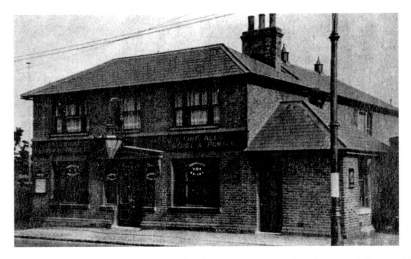

Seventy years ago, the Cherry Tree, Tonbridge Road, was advertised as follows: "Cherry Tree Inn, (opposite Barming Asylum, Maidstone) proprietor J. Horton, open to bona fide travellers on Sundays, good stabling and bicycles stored. The Cherry Tree Tea Gardens are recommended for visitors and families." Arthur Kemp was the licensee when this photograph was taken about 1929. The Cherry Tree and the Duke of Edinburgh in Heath Road (formerly Asylum Road) are still operating. The Invicta Inn occupied the premises next to the Cherry Tree in 1882.

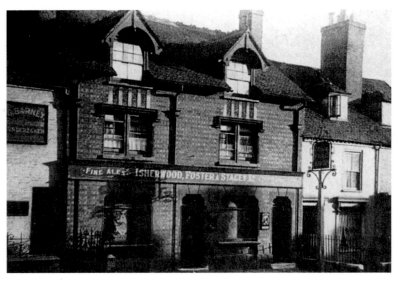

In 1929 George Barney & Sons, builders and undertakers, had their premises next door to the Union Flag in Union Street. This property has since been demolished and a large Union Jack is now painted on the side wall of the public house. Several years ago, a skittle alley, followed by a small bore shooting range, was set up at the rear of the premises. These amenities were well used by the staff of Wrens Cross Police Station. The Union Flag was transferred to Truman Ltd. In July 1979. A hundred years ago, the Bull & Snuffers Inn was a few doors along from the Union Flag.

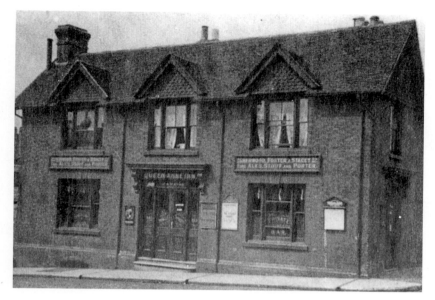

The Queen Anne, in Queen Anne Road, was an inn during the eighteenth century. When Fremlins took over in 1929, it had been managed by the Payne family for more than fifty years. James Payne, who was proprietor in 1882, was also a cooper. Three small beerhouses that were in this locality in 1882, the Albion Inn in Albion Place, the Huntsman in Astley Street and the Blacksmiths' Arms in Marsham Street have all since closed.

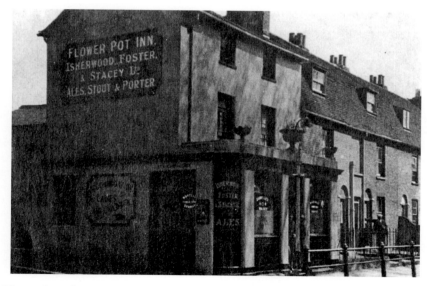

The Flower Pot, the Dragoon and the New Inn & Railway Hotel were the only surviving public houses in Sandling Road in 1929. The British Queen, the Duke of Cambridge, the Grasshopper, the Phoenix Tavern, the Royal Horse Artillery and the Prince Albert had all been closed. The Flower Pot, 91 Pleasant Row, Sandling Road, provided special accommodation for ladies and children and was a noted house for Dunville Whisky. It was transferred to Truman Ltd in July 1979.

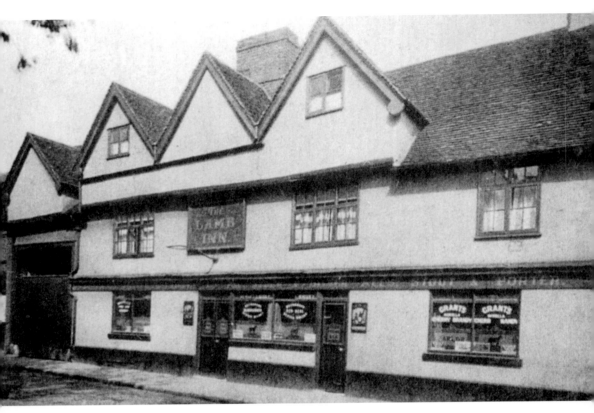

The Lamb Inn, Fairmeadow, was once a farmhouse and it was near here in 1557 that seven people were martyred for their faith. In 1692 the house was owned by William Broomfield, a yeoman and prior to being sold to John Brenchley, William Henry Stacey and Courtney Stacey in 1825 the premises had been used as a Carriers' business. In the early 1900s, the Lamb and the nearby Bridge Tavern were crowded when the pleasure fairs and cattle markets were held in Fairmeadow. The occasional flooding of the Medway caused some inconvenience especially when the Lamb's Bar was immersed in flood water. The inn continued to trade under the name of the Lamb until 1981 when Whitbread Fremlins restored the building exposing its original sixteenth century timbers. It has been renamed Drake's Crab & Oyster House. Henry Higgins, the landlord of the Lamb in 1882, previously managed a small beerhouse in Fairmeadow called the 'Who Would Have Thought It'.

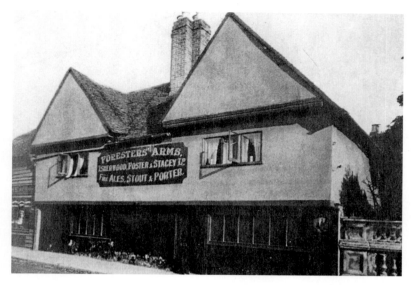

The Foresters Arms, Knightrider Street in the 1920s. Mrs Marshall, the proprietor of the Foresters for seventeen years, had to leave the premises in 1940, when a delayed action bomb fell through her bedroom into the saloon bar. A week later the bomb exploded when a member of the bomb disposal unit tried to defuse it. He was killed and the premises were destroyed. Fremlins acquired a wooden tea shack from Wrotham Hill and erected it as a temporary public house. When the Foresters closed on 10th October 1967, the wooden building was taken over by Young Enterprise.

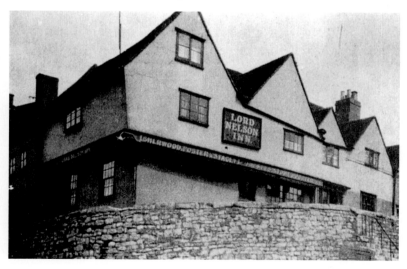

The Lord Nelson occupied the XIVth century house on the corner of St Faith's Street and Waterside. It catered for the boatmen and was generally believed to be a haunt for smugglers. When the Lord Nelson closed in 1938, the licence was transferred to the Sir Thomas Wyatt at Allington. This establishment is now called Cook Lubbock House. A hundred years ago there were two more beerhouses in St Faith's Street, the Beehive and the Chillington Arms. The Odd Fellows Arms, kept by William Hodges, was in Waterside in 1872.

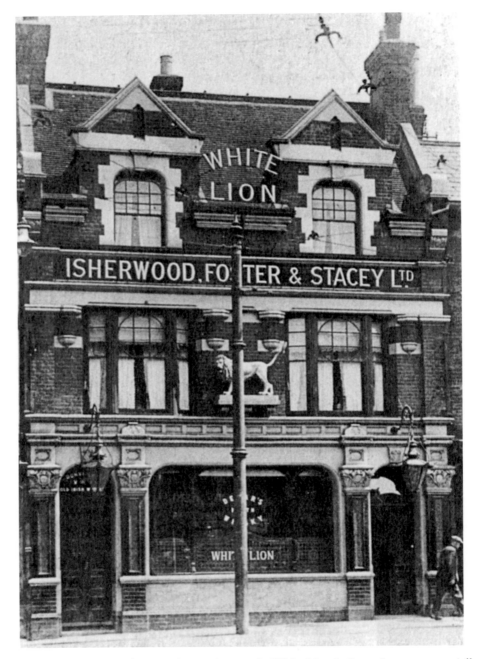

In 1929, the same year that Fremlins took over, the White Lion in Stone Street was partially destroyed by fire. The Co-operative Society next door, where the fire started, was practically burnt out. The White Lion was restored; and survived for almost another fifty years. It was closed on 1st January 1976.

The Town Arms and the Monk's Head were in Lower Stone Street in the 1800s. The Town Arms closed before 1882 and the Monk's Head closed in 1898 and was sold to John Arkcoll.

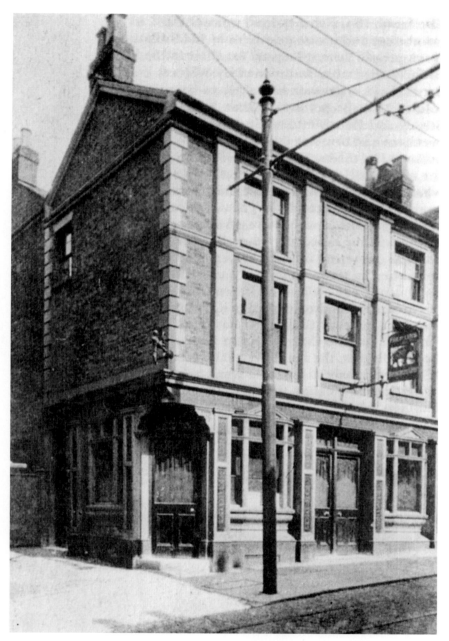

The Brenchley Arms is a memorial to the Brenchley family, previous owners of the Lower Brewery. During the latter half of the last century this public house was known as the Oak & Ivy. The Brenchley Arms is one of four remaining public houses in Upper Stone Street, the other three are the Pilot, the Fortune of War and the Papermakers Arms. (The latter was recorded as a general shop and beer retailer in 1882 and was run by Mrs Sudds.) This street had a long list of drinking houses last century which included the Crown & Anchor, the Duke of Brunswick, the Kentish Waggoner, the Ten Bells, Noah's Ark and the Plough.

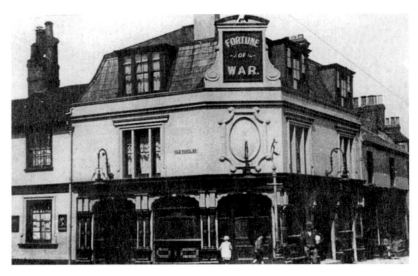

The Fortune of War, on the corner of Old Tovil Road and Upper Stone Street, was run by the Goodbody family for many years. William Goodbody was landlord in 1882 and his son William was in charge when Fremlins took control in 1929. Another of his sons took over the management of the Foresters Arms which he later exchanged with Mrs M. E. Marshall for the proprietorship of the Sun. Other members of this family were publicans at the Monk's Head in 1878, the Dog & Bear in 1882, the Roebuck in 1882, the Dog & Gun in 1903 and the Flower Pot in 1929. The Eagle, on the other corner of Old Tovil Road, has also remained.

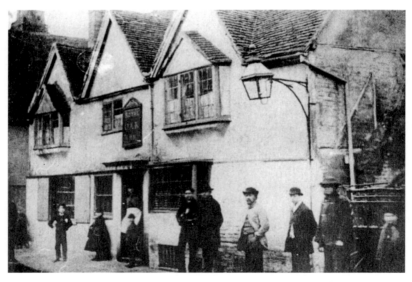

The Royal Oak, King Street in 1850. This old inn was one of four in King Street during the last half of the nineteenth century. The other three were the Dog & Bear, which closed in 1913 as shown on page 31 and the Royal Dragoon and the Three Tuns, both of which closed in 1916. It is interesting to note that Haynes Brothers bought the Three Tuns the following year and erected a Car Showroom and Garage on the site. This is where the King Street entrance to the Stoneborough Shopping Centre is today.

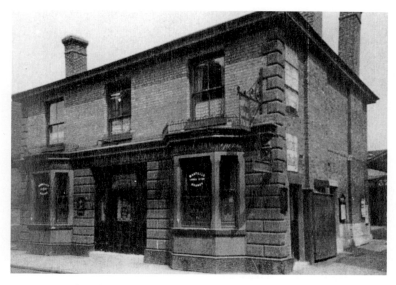

By 1929, a new Royal Oak had taken the place of its predecessor. Fred Usherwood was the landlord and the old yard and stabling had been replaced by a garage and car park. The Royal Oak was closed on 31st August 1975 leaving King Street without a single public house. Scotch Provident House is now on the site.

The Artichoke was in Ashford Road during the 1800s. When it closed in the 1890s, Michael Field had managed the inn for more than fifty years. A footpath used to lead to the Artichoke, through a five bar gate (known as the Artichoke Gate), from the top of King Street.

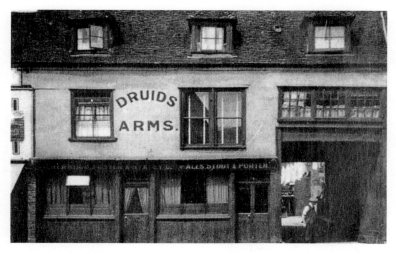

William Boozer was the proprietor of the Druids Arms, Earl Street in 1882 and he offered 'Good Beds, Fine Livery and Bait Stables, Open & Closed Carriages and Traps of every description let on hire.' This photograph shows the Druids Arms in 1929, just before it was modernised by Fremlins. A public house called the Jolly Waterman, kept by Charles Barnett, was recorded in Earl Street, (on the corner of Havock Lane), in 1839. By 1872 the premises had been renamed the Crown and were managed by William O'Kill. The public house had closed by 1882.

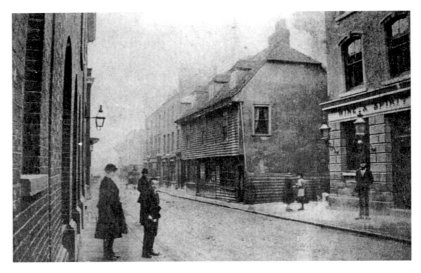

A photograph of Week Street taken in the late 1800s from the lower end of Brewer Street. The West Kent Hotel can be seen on the right and the passageway at the side was one of the entrances to Bone Alley. The Two Brewers occupied premises in this part of Week Street until the 1870s.

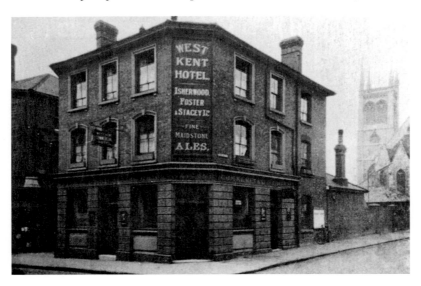

The West Kent Hotel in 1929 when Scott Gibson was the proprietor. He offered good accommodation for commercials and an added attraction was a photographic display of actors and actresses of bygone times. The hotel was closed on 20 September 1970 and Curry's electrical shop stands on this corner today. When the London, Chatham & Dover Railway opened at Maidstone East in 1874 two public houses at the top of Week Street were re-named. The Compasses became the Railway Guard and the New Inn became the New Inn and Railway Hotel. (The Railway Guard closed at the beginning of the century and the latter became the present Wig & Gown.)

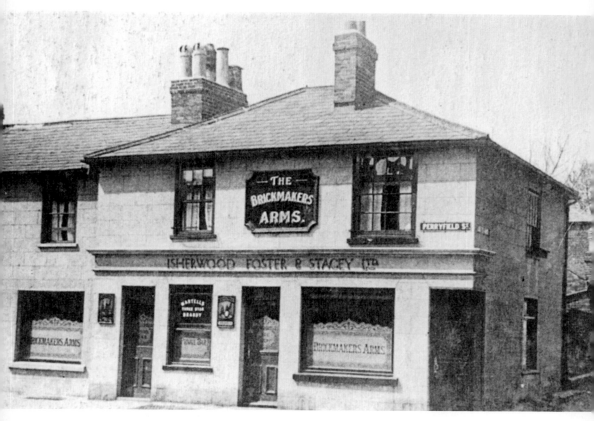

A.H.W. Dalton was the licensee of the Brickmakers Arms, Perryfield Street, when it was taken over by Fremlins in 1929. These premises, together with the Fisher's Arms in Scott Street, the Wheelers Arms in Perry Street and the Holly Bush in Fisher Street, have all served this part of Maidstone for more than a hundred years. The Half Way House was also in Perryfield Street in 1882 but it closed in the early 1900s.

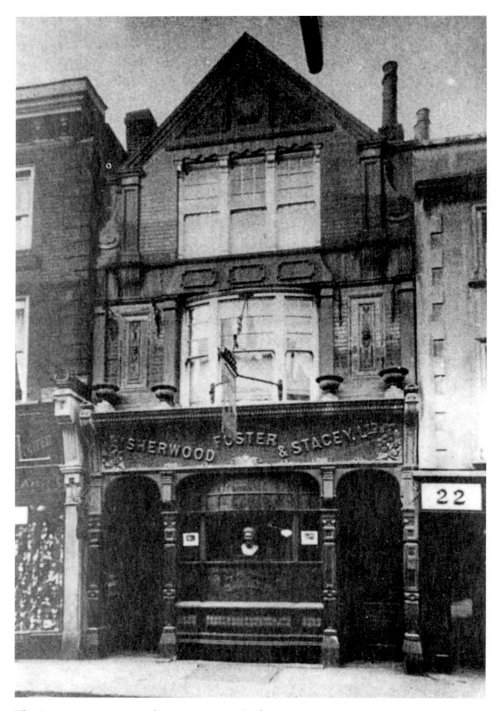

The Fountain was a typical Victorian inn. The front was faced with blue-green embossed tiles and from the window, a smiling figurehead looked out on Week Street.

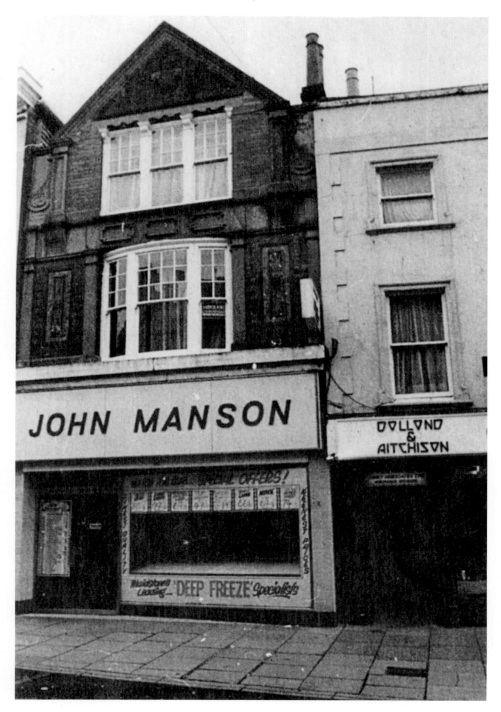

The Fountain closed in 1969, the colourful facade was removed and the premises became a butcher's shop. The optician's next door used to be a Style & Winch off-licence.

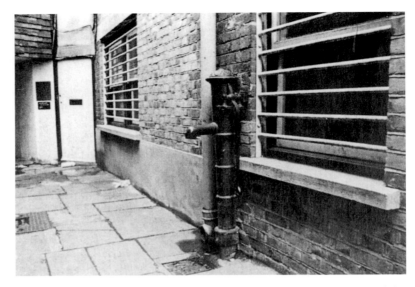

This Victorian water pump, which was so familiar to the customers of the Fountain in years gone by, can still be seen in the passageway between John Manson's and Dolland & Aitchison's.

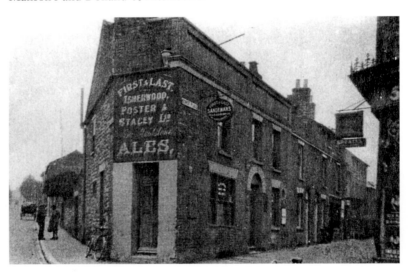

The First & Last on the corner of Bower Lane and Bower Place, was built in 1835 and was opened as a beershop. A few years later it was purchased by the Lower Brewery from Thomas Holloway, a beer-seller. These premises have changed very little since this photograph was taken around 1929. It is interesting to note that all the public houses that were in this part of town in 1882, including Bower Inn along the Tonbridge Road, are still in business. Walter Fremlin lived at Rocklands on the corner of Bower Place (now West Borough Club) in the late 1800s and it is reputed that several new roads that were built in the locality were named after his children e.g. Florence Road, Douglas Road, Reginald Road etc.

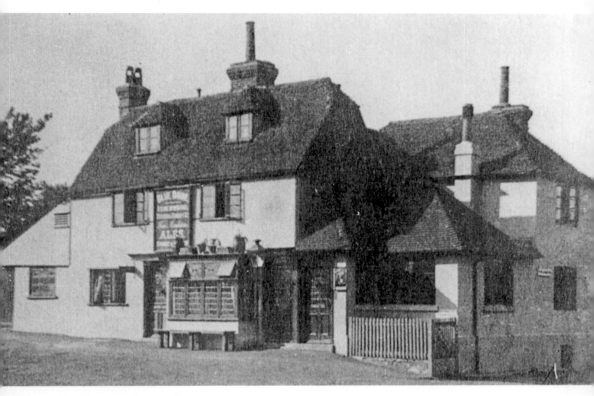

This public house at Broadway, Sutton Road, was originally called the Blue Bell but when John Brenchley and Flint Stacey purchased the property from Thomas Argles in 1790 it was known as the Bell. According to a newspaper cutting, the door of the Bell was painted blue during an election in 1880 and the public house came to be known as the Blue Door. In fact it was officially renamed the Blue Door in February 1929. In 1957 a new public house was built alongside, the old building was demolished and the licence was transferred to the new premises. On the 4 December 1980 the public house was re-christened the Broadway Belle and the interior was furnished in the 1920s style.

At the end of the last century the Malta, Boxley, named after one of our former naval stations, was a small, unpretentious riverside inn used mainly by hikers, boatmen and fishermen. A few years ago it was transformed into an elegant hostelry. But times have changed, in December 1981 a 'new look' Malta opened as a Beefeater Steakhouse.

Chapter 8
Mason's Public Houses

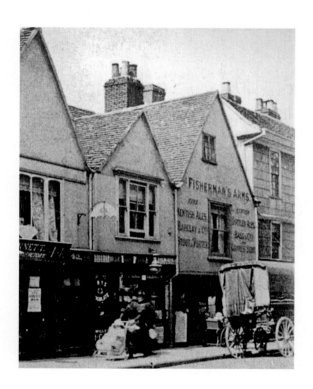

Mason's Brewery maintained several licensed premises in Maidstone including the Fisherman's Arms in Lower Stone Street. When this photograph was taken at the turn of the century, a greengrocers shop took up a large proportion of the ground floor. This was removed in 1916 when the bar was extended. The Fisherman's Arms is probably the oldest public house in the town, the building, which is listed, dates from about 1430. The house on the right of the Fisherman's Arms was the home of the Brenchley family before they moved to Kingsley House.

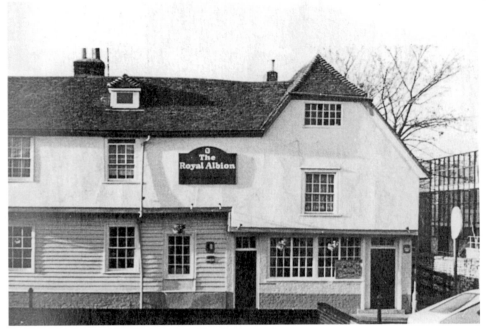

The Royal Albion in Havock Lane is another listed building. These premises were managed by the Hawks family from 1882 until the 1930s.

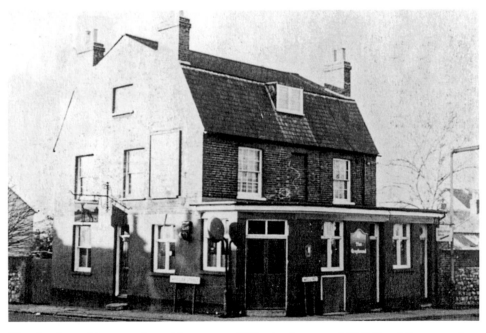

The Greyhound has stood on this corner of Wheeler Street and Well Road for more than hundred years but during the early 1800s the Bricklayers Arms occupied this corner.

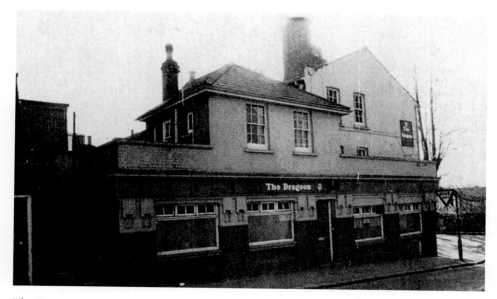

The Dragoon, opposite the Barracks in Sandling Road, has always been popular with the army. During the air raid on Maidstone on 27th September 1940, the landlord and his wife, Mr & Mrs Payne, escaped unhurt when a bomb demolished the rear of the Dragoon. The premises were later restored.

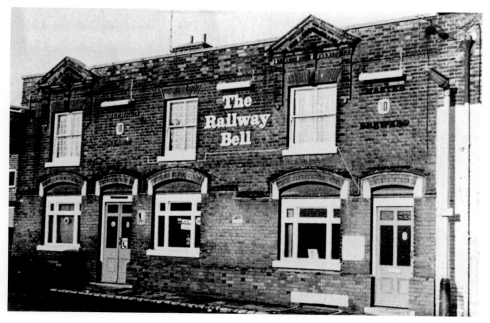

When the Stock Market was moved from Fairmeadow to Lockmeadow in 1920, business increased considerably for the Railway Bell in Hart Street. It is still called a 'market pub' today. Apart from the White Hart, which has already been mentioned, there was another beerhouse in Hart Street one hundred years ago, called the Royal Oak. It had closed by 1902.

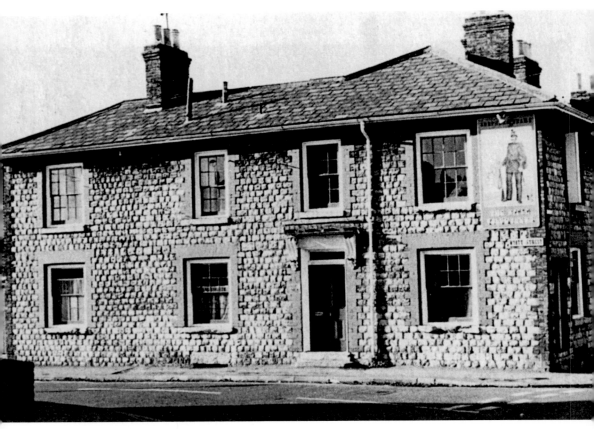

The Rifle Volunteers is the only surviving public house in Wyatt Street. The Kent Arms closed when this area was modernised in the 1960s and the Buffaloes Head closed years earlier.

Mason's other public houses were the Swan on the corner of County Road and Woollett Street (the County Arms occupied this corner in 1848), the Dog & Gun in Boxley Road and the Wheelers Arms in Perry Street. All of these are now Shepherd Neame houses.

Chapter 9

Other Brewers &
Free Houses

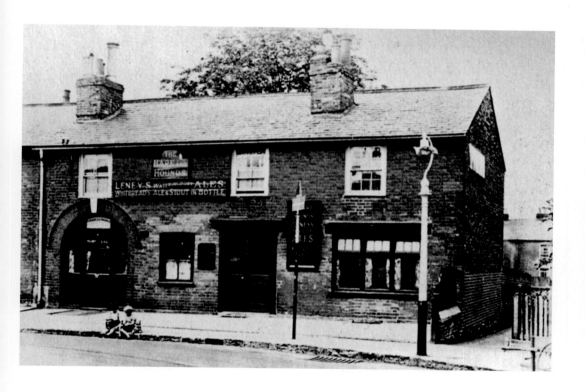

Although the majority of the licensed houses in Maidstone were either tied to the Medway Brewery, Fremlins or Masons in the early years of the century, there were a few that were either free houses or tied to other brewers outside Maidstone. The Hare & Hounds in Lower Boxley Road was a Leney house. It was always popular with the armed forces and it was outside here in 1975 that an IRA bomb exploded under a parked car causing several injuries and severely damaging the public house. The Hare & Hounds was later rebuilt.

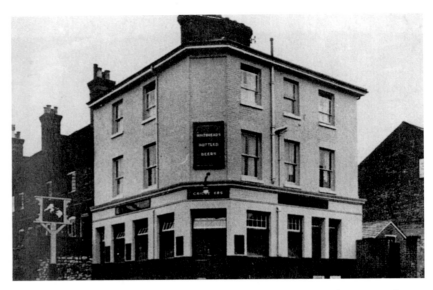

The Cricketers Inn, Mote Road, conveniently near Mote Cricket Ground, was another Frederick Leney house. In 1941, a new inn sign for the Cricketers was made at the sign shop in Wateringbury. It shows three cricketers waiting to see the fall of a coin. A smaller version of the sign was hung in the bar. There were two other public houses in Mote Road, the Rose Inn, which closed around 1900 and the Carpenter's Arms which closed in 1915. A postcard showing the Carpenter's Arms can be seen on page 23 in 'Old Maidstone', Vol.I.

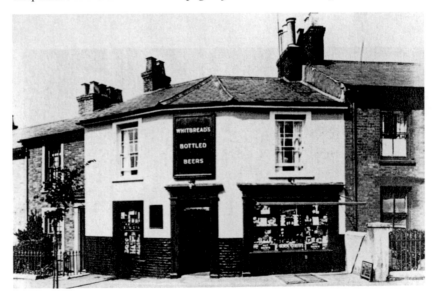

The off-licence in Scott Street after it had been taken over by Whitbreads in 1930. This shop had been a beer retailers for many years and from 1882 till the First World War, it was run by William Bonner as a green-grocers and beer shop. The off-licence was closed in the 1960s.

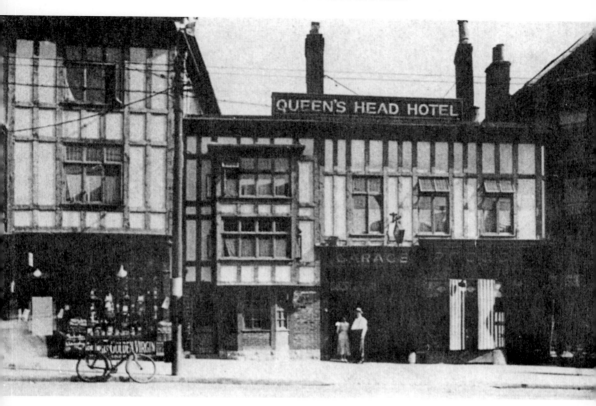

The Queen's Head, another Leney house, was one of the principal coaching inns in Maidstone during the early nineteenth century. It housed the General Coach Office where passengers could book for the superior fast coach, the Balloon, which left the Queen's Head every morning at 9 o'clock (Sundays excepted) to Oxford Street. Fares were: inside 10s – outside 6s. The Times Coach also stopped at the Queen's Head on its route to Folkestone. Until the late 1920s, carriers stabled their horses at the Queen's Head and left their carts in the middle of the lower High Street. Another coaching inn called the Swan occupied premises further up the High Street prior to 1852.

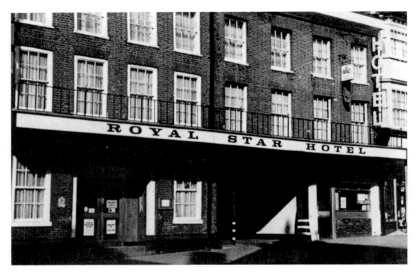

The Royal Star has probably been one of Maidstone's most notable inns. It was here in 1642 that the Kentish Petition was discussed on the eve of the Civil War and in 1837, from the first floor balcony, Benjamin Disraeli thanked the electors for making him their member of parliament. In 1924 the inn was altered and parts that had previously been covered up, were restored. In the 1930s, Charles Betts, who already owned a sweet shop in the High Street, noted for its 'Bettina' home made toffee, purchased the Royal Star from the Medway Brewery. He was the proprietor for many years and had many additions made to the premises including the King's Hall and Star House in Pudding Lane. The Royal Star is an Embassy Hotel today. Two earlier views of the Royal Star can be seen in 'Old Maidstone' vols 1 and 2.

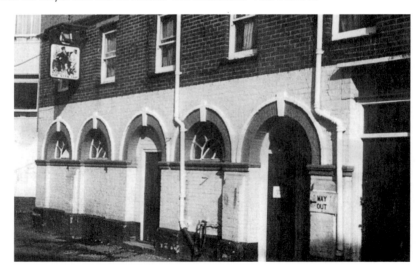

The Royal Star Tap, as it is today, situated in the yard of the hotel. The coaching and stabling facilities which were nearby and catered for 71 horses, are now converted into an extensive car park. It is reputed that the hotel's name was changed from the Star to the Royal Star on the occasion of a visit of Queen Victoria as a young girl and her mother, the Duchess of Kent.

Chapter 10
More Early Closures

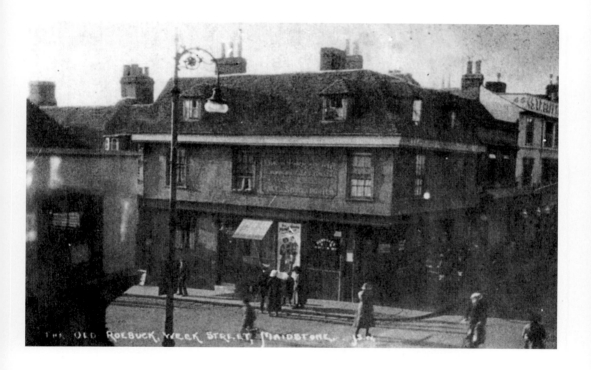

The Roebuck stood on the corner of Week Street and Earl Street for nearly a hundred years and when it was closed for compensation on September 30th 1920 it was greatly missed. Hepworth Ltd have the premises on this corner today. A previous Roebuck was in Mote Road at the beginning of the nineteenth century.

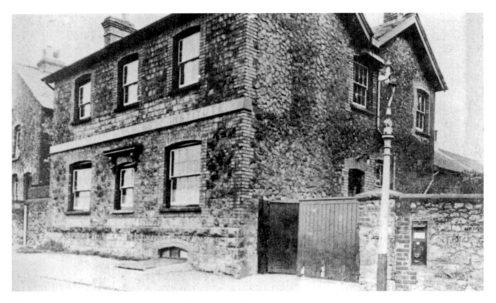

The Barming Heath Workmen's Institute, Queens Road about 1930. This property had previously been a Jude, Hanbury & Co.'s public house called the Greyhound and was closed for compensation in 1917. It re-opened as a Working Men's Club in 1921. In 1969 it became a public house again and was named the Saxon Chief. The inn sign and a picture in the Public Bar portray Beormund, a Saxon Chief, who lived in this district with his tribe.

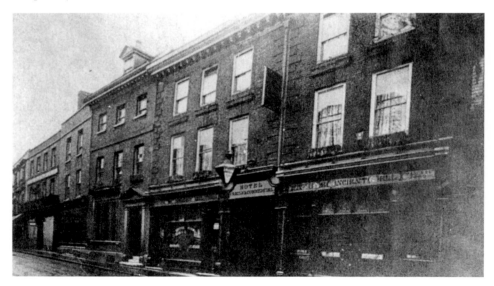

Ye Ancient Bell Hotel in Week Street closed in the 1920s. This was a very old inn and apparently was re-named when the Bell Inn on Gabriel's Hill was closed at the beginning of the eighteenth century. The Bell and the Royal Star were the town's posting houses. Towards the end of the eighteenth century, postboys were often seen in front of the Bell waiting to take out the bright yellow post chaises which were advertised for hire from hotel at 9d a mile. Freeman Hardy & Willis and Art Wallpapers have these premises today.

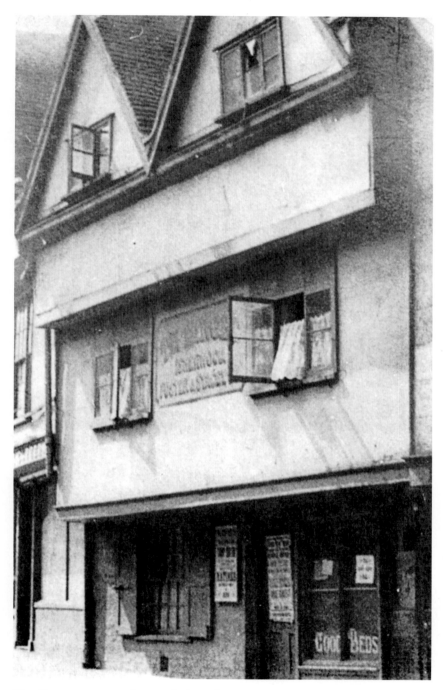

The Target was one of many lodging houses in Stone Street at the turn of the century. It was also a typical Victorian ale house which catered for the less well-to-do. The Target became redundant on 31 December 1910 and was later demolished to make way for the present bus station.

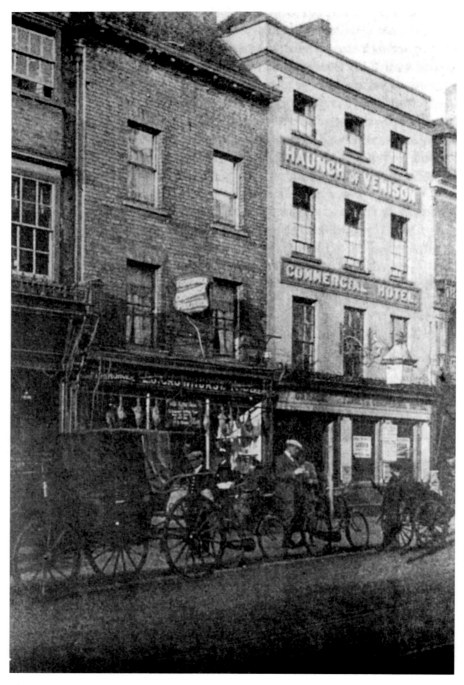

The Haunch of Venison at 12 High Street was a Commercial Hotel, advertised as 'the most central house for cyclists'. When Henry Arthur was proprietor in 1900, his stables were highly recommended. The hotel was sold on 2 February 1918 to the London Guarantee and Accident Co. Ltd for £2,700. Truform Shoes are at 12 High Street today.

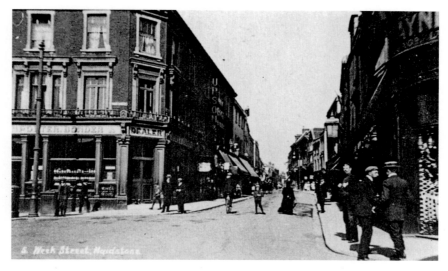

When the Red Lion closed on the corner of Week Street and High Street after the Second World War it was the end of an era. A Red Lion had occupied this location for more than three hundred years. In 1650 it had belonged to John Saunders of the Lower Brewery. Richard Norden, an independent wine & spirit merchant, ran the business in 1882. He was followed by William Wallace & Sons. The Red Lion came to be known as the Gin Palace as it had a small bar for ladies only. Wallaces imported great casks of wine and the empties were always piled outside for sale. The Red Lion's main attraction was a unique upstairs balcony where bands played in the evenings. A postcard showing the previous Red Lion (which was demolished in 1857) can be seen on page 1 of 'Old Maidstone' vol. 2.

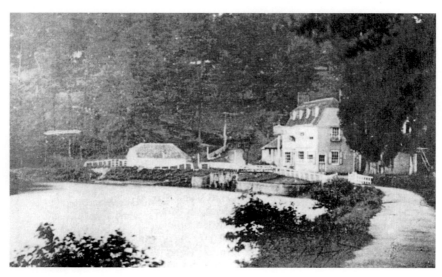

The Gibraltar at Sandling, also named after a naval station and only a short distance along the riverbank from the Malta, was only accessible by water or foot. It was much frequented on Sunday evenings and the area was very popular for school treats and picnics. This old inn with its swinging sign closed over a hundred years ago.

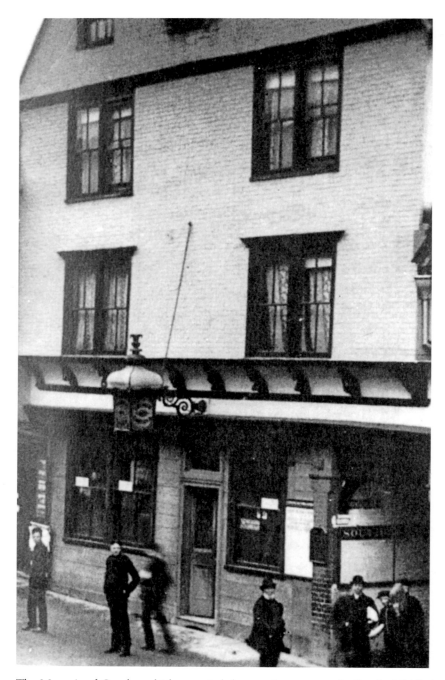

The Marquis of Granby, which occupied the premises next to the Sun in Middle Row, became redundant in 1904. The property was sold to the London & Provincial Bank. Barclays Bank occupied this site for many years, then Seeboard and now the Bristol & West Building Society. There was a small tavern called the Ball in Middle Row, next to the Town Hall, until the early years of the nineteenth century.

The ornamental roses over the windows of the Woolwich Equitable Building Society in the High Street, are a reminder of the Rose Inn that-was here in the seventeenth century. In all probability it was the first brick house to be erected in the High Street. This same building was occupied by the Carlton Cafe for many years. Tucked away along Rose Yard, was the Turk's Head which was once kept by Philip Woollett, the father of Maidstone's famous engraver. The inn was closed in the early 1900s.

Maidstone Public Houses and Beerhouses of 1882

As the previous pages have shown, several licensed premises have been closed during the last hundred years. The following list of Maidstone's public houses and beerhouses of 1882 has been marked with asterisks to show those which remain open at the present time under the same name.

INN SIGN	PROPRIETOR	ADDRESS IN 1882
* Admiral Gordon	William Dray	161 Tonbridge Road
Albion Inn	Mrs R. Hinman	32 Albion Place
* Anchor & Hope	Edward Avery	48 Bower Place
* Ancient Druids	Luke Dann	73 Brewer Street
Artichoke	Michael Field	Ashford Road
* Artillery Arms	Charles Bowes	16 Thornhill Place
Beehive	Robert Jones	12 Faith Street
Bell	William Avard	Sutton Road
Bell (Ye Ancient)	Frank James Wain	26 & 28 Week Street
Blacksmith's Arms	Charles Wise	27 Marsham Street
* Bower Inn	Joseph Banks	Tonbridge Road
* Brickmakers Arms	George Berry	107 & 109 Perryfield Street
* Bridge House Hotel	Robert Dunk	2 London Road
Bridge Tavern	William Bowes	6 & 7 Fairmeadow
British Queen	William Brewster	58 Sandling Road
* British Queen	John Hayward	9-11 Square Hill
Brittania Arms	William Constable	3 George Street
Buffaloes Head	Thomas Benjamin Bristow	41 Wyatt Street
Bull & Snuffers Inn	Jno. Fry	72 & 74 Union Street
* Bull Hotel	Frederick E. Wyburn	9 Gabriel's Hill
* Bull Inn	Egbert Punnett	Penenden Heath
Cannon	Post Office	86 Hardy Street
Carpenters Arms	Jno. Slender	69 & 71 Mote Road
Castle Hotel	William Boozer	6 & 8 Week Street
Chairmakers Arms	Edwin Walters	11 George Street
* Cherry Tree	S. J. Hobbs	Tonbridge Road
Chillington Arms	Mrs E. Brain	10 Faith Street
* Cricketers Inn	C. Rous	48 Mote Road
Crown & Anchor	George Waters	43 Upper Stone Street
Dog & Bear	John Goodbody	37 King Street
* Dog & Gun	R. J. Merrony	215 Boxley Road
Dragoon	Mrs H. Hunt	39 Sandling Road
* Druids Arms	William Boozer	24 Earl Street
Duke of Brunswick	Thomas Coatsworth	28 & 30 Upper Stone Street
Duke of Cambridge	Edward Woollett	32 Sandling Road
* Duke of Edinburgh	Miss E. Ray	Asylum Road
* Duke of Marlborough	Joseph Pearch	25 Union Street
* Eagle	Mrs E. Clark	56 Brewer Street
* Eagle	James Lindridge	138 Upper Stone Street
Elephant & Castle	John Duff	1 Tonbridge Road
* Fant Arms	Mrs A. M. Constable	Upper Fant Road
* First & Last	Edward Morris	40 Bower Lane
* Fishermans Arms	John Beeney	40 Stone Street
* Fishers Arms	Charles Frederick Bow	40 Perryfield Street
* Flower Pot	William King	91 Sandling Road

Pub	Licensee	Address
Foresters Arms	George Francis Martin	13 Knightrider Street
Foresters Arms	Isaac Salmon	58 Church Street (Tovil)
* Fortune of War	William Goodbody	126 Upper Stone Street
Fountain	George Benzie	24 Week Street
* Fountain	George Cruttenden Dann	Tonbridge Road
* Fox Tavern	William Waghorn	29 Hartnup Street
Gardeners Arms	Mary Sharp	27 Earl Street
Globe	John Potter	20 Knightrider Street
Good Intent	James Stone	23 Camden Road
Grasshopper	R. Horden	92 Sandling Road
Greyhound	Mrs E. Richards	Scrubbs Lane (Queens Rd)
* Greyhound	Joseph Wicken	77 Wheeler Street
Half Way Home	Joseph Johnson	33 Perryfield Street
* Hare & Hounds	Thomas Frederick Hearnden	47 Boxley Road
Haunch of Venison	Henry Arthur	12 High Street
Hearts of Oak	Mrs Jeffrey	102 Week Street
* Holly Bush	Benjamin Ladd	38 Fisher Street
Hope & Anchor	Charles Smith	24 Union Street
Huntsman	John Collins	21 Astley Street
Invicta Inn	Charles Datsun	Tonbridge Road
Kent Arms	Charles Coppin	22 Wyatt Street
Kent Arms	Mrs Anne Hayward	30 Medway Street
Kentish Waggoner	William Dove (senior)	80 Upper Stone Street
King's Head	Charles Warren	46 High Street
* Kingsley Arms	James Orman	8 Brunswick Street East
Lamb	Henry Higgins	12 Fairmeadow
Little Star	George Saxby	2 Woollett Street
London Hotel	George Robert Butcher	110 Week Street
Lord Nelson	Charles Aland	62 Faith Street
Maid of the Mill	Mrs Anne Pembroke	Padsole Lane
Maidstone Restaurant	Joseph K. Tapsfield	73 Bank Street
* Malta Inn	Mrs Elizabeth Sills	The Riverside (Boxley)
* Market House	Jas. Bushnell	30 Earl Street
Marquis of Granby	George Camfield	10 Middle Row
Marquis of Lorne	John Henry Stone	10 Sandling Road
Marquis of Lorne	George Thomas Ditcher	114 Kingsley Road
* Mitre Hotel	Spencer & Son	The Market, High Street
Mitre Shades	Moses Sprange	The Market, High Street
Monk's Head	Richard Pattenham	139 Stone Street
Morning Star	Nye Mark	48 Boxley Road
Nag's Head	George Henry Lockyer	76 Week Street
New Inn & Railway Hotel	Charles Grey Long	1 Sandling Road
Noah's Ark	John Andrews	106 Upper Stone Street
Oak & Ivy	Edward Jenner	65 Upper Stone Street
Old English Gentleman	George Young Gouge	Church Street (Tovil)
* Old House at Home	George Wood	22 Pudding Lane
Parliament House Inn	Thomas Chambers	12 Wharf Lane
Phoenix Tavern	Mrs Heal	5 Sandling Road
* Pilot	William Burville	21 Upper Stone Street
Plough	Charles Mason	120 Upper Stone Street
Prince Albert	Thomas Squibbs	44 George Street
Prince Albert	Henry Cullen	13 Sandling Road
Queen Anne	Jas. Payne	11 Queen Anne Road
* Queen's Head Hotel	William Davies	62 & 63 High Street
* Railway Bell	Mrs C. Beeching	33 Hart Street
Railway Guard	Jas. Godfrey	120 Week Street
Railway Guard Tap	Jas. Godfrey	1 County Road
* Railway Hotel	Timothy Epps	11 Tonbridge Road
Red Lion	Richard Norden	1 High Street
* Rifle Volunteers	Augustus Beaumont	28 Wyatt Street
* Rising Sun	Henry Akhurst	22 Marsham Street
Roebuck	John Goodbody	41 Week Street
* Ropemakers Arms	William Cook	50 Bower Lane
Rose Inn	Walter Hills	35 Mote Road
* Rose Inn	Henry Marchant	119-121 Wheeler Street
* Rose Inn	William Hodges	Farleigh Hill (Tovil)
Rose & Crown Hotel	W.W. Brissenden	37 High Street
Rose of Denmark	Henry Kettle	16 Market Street
* Royal Albion	Henry Hanks	23 Havock Lane
Royal Dragoon	J. Thompson	59 King Street

* Royal George	Mrs Sarah Knight	2 Boxley Road
Royal Horse Artillery	William Froud	36 Sandling Road
Royal Oak	William Usmar	89 King Street
Royal Oak	Robert Wickenden	10 Hart Street
* Royal Paper Mill	Frederick William Swift	39 Tovil Hill (Tovil)
* Royal Star Hotel	Joseph Keeley	15 High Street
* Running Horse	William Ward	Sandling
* Seven Greys	Joseph Dence	23 St Peter's Street
Ship	Charles Tassell	33 Gabriel's Hill
* Sun	A.C. Brissenden	11 Middle Row
* Swan	Robert Harrison	15 Woollett Street
Target	Thomas Beadle	16 Stone Street
Ten Bells	T. Pilbeam	96 Upper Stone Street
Tichborne Arms	Frederick Akhurst	106 Week Street
Three Tuns	James Bratton	18 King Street
Turk's Head	Jas. William Watts	Rose Yard, High Street
* Union Flag	Mrs. B. Beeching	62 Union Street
* Victoria Hotel	Mrs Hands	Week Street
* Victory	George Drowley	23 Church Street (Tovil)
* Walnut Tree	J. Hayward	20 Laurel Place, Tonbridge Road
Wellington	James O'Neil	10 Mill Street
West Kent	Edward Shaw	97 Week Street
* Wheatsheaf	John Hickmott	Loose Road/Sutton Road
* Wheelers Arms	George Grover	1 & 3 Perry Street
White Hart	George Russell	36 Hart Street
* White Horse	John Liberty Simpson	29 London Road
White Horse	Henry Jury	Farleigh Hill (Tovil)
White Lion	J.V. Newman	53 Stone Street
White Swan	Fred Dearing	3 St Peter's Street
Windsor Castle	Mrs E. Bramble	72 Week Street

Fremlin Bros brewed a variety of ales and beers at the turn of the century including the following:-

Bitter Beer	XX	Stock Ale
Bitter Ale	XXX	Stock Ale
Indian Pale Ale	XXXX	Stock Ale
Double Stout	Single Stout	

Ales and Beers were 'specially adapted for private families'. Drays, pulled by the famous Fremlins Greys, 'ran through the usual districts in the Maidstone area every week'.

Their beers were 'guaranteed to be bittered entirely with English hops and to be kept throughout the summer'.

Fremlins special English Ale was recommended by the medical profession.

Style & Winch had a similar variety of ales and beer which they delivered to their fully licensed houses, beer-houses and off-licenses. This firm was one of the earliest to use the steam lorry, the Straker in 1902 and the Foden from 1904.

Style & Winch prices for a 36 gallon barrel in 1903 were as follows:-

Table Ales	30/-
Best Bitter	36/-
Pale Ale	42/-
India Pale Ale	50/-
X	36/-
XX	54/-
XXX	63/-
Porter	36/-
Stout	50/-
Maidstone Pale Ale	2/6d per doz pints
Stock Ale	3/6d per doz pints